Enduring Justice

Photographs by Thomas Roma

*

Thomas Roma

ENDURING JUSTICE

FOREWORD BY

Norman Mailer

*

INTRODUCTION BY

Robert Coles

powerHouse Books · New York

FOREWORD BY NORMAN MAILER

THIS book of photography by Thomas Roma is wed to a perfect title. To the man or woman in the dock, and to their family and friends, justice is a state that is there to be endured. For justice comes down to long dead hours of sitting around. Justice consists of waiting to speak to your lawyer who is never with you long enough and charges more than you can afford while all the while he emanates his profound dissatisfaction with what he is being paid. Justice is the hard small ball of concentrated dread in the pit of the stomach that suggests it will never dissolve. You are in the pits and you are enduring it.

Justice is the smell in the smoke of the bail bondsman's cheap cigar as the fumes drift down the dire corridors; justice is the look in the judge's eye when he is debating whether to call another recess for his bladder; justice is the look your woman gives as she hands your crying baby over during recess. Justice is what you pay for getting caught. You will not be able to measure the cost in money: you are living with the knowledge that one way or another, you are going to be less of a man when it is all done.

Justice is equal to living in the mood of an overcrowded men's room for the rest of your days. Justice will more than make you pay for the highest pleasure you felt in the highest moment of the crime. The final horror of justice is looking at your kids. Either their eyes are in misery or their mouths are numb.

And the wives, the girlfriends. How deadening are their emotions! If they are not bitter, then they are kin to despair. They know that danger is approaching— the danger that soon they will feel nothing at all. The women stare into the bleak eye of the future—no man, no money, and too many kids.

Justice is taking such a whack at your ego that the only way to restore yourself is to go out and pull another caper. Self-respect is what crime is all about. Self-respect—usually to be followed by the second act—enduring justice.

These photographs have the eloquence and resonance of the best literature on the most unhappy subjects.

INTRODUCTION BY ROBERT COLES

Ahead are the photographs of a talented, resourceful, morally energetic social observer whose work has helped many of us look carefully, and with surprise, at the fellow citizens whom he has attended so thoughtfully with his camera. Many of us know Tom Roma's street photographs, his continuing effort to track down Americans at home, in certain neighborhoods, even on the subway, on their way to one or another destination, but here we are asked by him to concentrate our attention in a newly focused and demanding manner—to enter a building where the fate of men and women is being settled by lawyers who argue, judges who decide, and of course, police officers who declare what happened, where, and why. This book tells that story—of individuals who have been caught doing something illegal, or of individuals who have been mistakenly charged for doing so: people in a city's court building because something has happened to others, or to them. A misdemeanor, a crime, an episode of wrong-doing has been noted, reported, and evaluated. As a consequence, accusations have been made and investigations have been put "on the record"—society's way of saying that the matter is serious and has to be examined formally (with bureaucratic procedures that have their own momentum).

Memorably, Franz Kafka wrote of all this in *The Trial*, which explored through fiction the hurdles, mysteries, and wrong turns of omission and commission that can confront people who ultimately get caught in a courtroom, and along the way, appear in the various places where officers of the law have their say and exert their will. In that regard, an esteemed Federal Judge, Learned Hand, commented on his own work, and that of others who arrest, arraign, and confine the thousands of American men and women known as suspects and defendants, whom can be found in the many hundred courts across our nation. In a 1958 interview conducted in his Manhattan home by his beloved grandson, Robert

Jordan, Hand spoke with a characteristic verve and flourish as he reflected upon his many years as lawyer and judge:

Sometimes, I've looked at those in front of me, on trial, and wondered how in the world they've gotten themselves into this—Kafka had it right: the bad twists and turns that can pile up, bring someone down. Gravity shadows us in those courtrooms. Often someone gets a coughing fit, and the doctors are summoned. Sometimes, though, the problem is not asthma, or "nerves," or a common cold, but someone's cry of disappointment and fear that prompts the throat to ache, the lungs to fill. Hovering over everyone is the shame some feel, their awareness of personal wrong-doing, or the awareness that others have evidence of wrong-doing. No matter what is said, no matter every denial spoken, [with] every charge, indictment, incrimination put on the table, there is a torrent of words [which] those brought to justice must hear and read, and in their heads try to follow, figure out well enough to comprehend truly, fully.

I often remember one moment in my courtroom. It was a "slow trial": bombast and plots and counter-plots (lawyers at work, doing what they had to do) and the woman caught in it all (a tax case, as complicated as they come!) suddenly lost her cool, lost it completely—she asked to say something, asked me directly, rather than through her attorney: "I give up!" Those were her words, three short ones—and suddenly the entire room was spellbound. Her lawyer rushed to her side, talked with her (to her!); she stared into space, not at the lawyer. I thought she'd lost control of herself—was in psychiatric trouble. I was getting ready to stop the trial, try to get medical help for her. "Are you alright?"—those were my words. She looked right toward me then. It was eerie! A long silence. I could hear people moving in their chairs. I crossed my legs. I had my hand on the gavel. I was about to call a recess, then ask to see her with her lawyer,

her daughter, who was sitting near her. Then she spoke: "Your Honor, I'm alright, but all this is wrong—wrong as can be!" I wasn't sure what to do! I decided to stop us all in our tracks—her and her lawyer, and the district attorney and his assistant, and me. We hadn't gone to a jury—we were just getting going, a fact-finding time. I was about to call a recess, and then she spoke again: "Maybe I deserve to be punished by the Lord, but I can't believe this is the way to find out the truth—no, your Honor!" Well, in no time we were in recess, and then I saw her in my chambers with her daughter, a young architect, I remember. I asked to talk with them alone, the two—and I did. This was a woman of composure and intelligence, I realized right away! She apologized immediately for what happened: "Your Honor, I shouldn't have spoken like that—it's against the law, it's wrong." I told her I could understand how hard it all was for her. She thanked me—and then she said this: "It's all so *impersonal*! It's *confusing*—to me, at least. That's what I wanted to say—I wanted to tell you that right or wrong (I believe right) I'm willing to accept whatever you decide, because I am being punished right now, sitting in that courtroom, trying to follow what people are saying, but getting lost. That's how I feel, *lost*!"

I still remember her way of putting things. That word "lost," it echoes in my head! I almost turned philosophical, if not religious, and told her "madame, we're all lost at certain times in this life"; but I knew that would get us—well, all of us, even more lost! I promised her we'd do our best to get through this—and we did. Naturally, I had to talk with myself, be careful and cautious, be sure I wasn't being "tricked" (manipulated). If I got too concerned with her, became "lenient," the prison and courtroom psychiatrists would then think: a sociopath at work! (They have their cautionary language!) Anyway, she wasn't found criminally guilty, but

she wasn't let off there—she was fined, a compromise. No one wanted her in prison, not the government [we had asked about the outcome]. I won't ever forget her honorable struggle, I thought it was to *understand* what was taking place, and to be as much *herself* as she could be, under the circumstances, [at] a time when we all lose ourselves—as she was trying to say: when someone gets immersed in the workings of a trial, the proceedings of a court, the justice system, that person may no longer be the same—may feel "lost."

As I looked at the photographs that follow I began to realize that the psychology (the personal drama) that that astute, attentively observant, and independent judge had once witnessed (and experienced) in a courtroom are also to be found in this book: the struggle of various Americans to find themselves, to get a grip on their emotional moorings, to steer clear of all sorts of perplexing and scary legal imperatives as they descend upon one's eyes, ears, thoughts, anticipations, expectations, amidst a series of events that have their own momentum, logic, prompt their own requirements, madness, obligations. As Kafka long ago knew to tell us through the magically suggestive and provocative workings of his novel's urgent symbols and metaphors, to "endure justice," as Tom Roma puts it (he, a photographer with a poet's sensibilities) is to be put at a remove from the thrust of one's life—to be lined up, turned over to others who wield authority and exercise power. To be sure, justice is desirable and necessary, but it can err, make mistakes, extract submission—obedience—from those who are, finally, innocent (as it has, now and then, turned out across our nation, and can again). Thus, for each person who faces those judges, courtroom officers, clerks, probation officers, policeman and sheriffs, there is on some occasions, a possibility of proper and due punishment, or, on others, of injustice done in the name of justice. Moreover, factually guilty or not guilty, a person can be humiliated, insulted, scorned—the improper consequences of a system gone awry, that has become "lost," while

it seeks to find itself. To carry forth the metaphor Judge Hand's story conveys, someone was "lost," but as a jurist recalled years later: "We all were getting lost, I began to feel first, think later." He was not, as it is put down South, "making a federal case" of that event, but he was very much intent on remembering, taking seriously, the occupational hazards that can afflict a group of professions, his own included, which, in their sum, constitute "justice" as it is meted across America daily.

As this book's visiting readers, viewers will soon notice a brilliantly watchful and knowing photographer has enabled us to contemplate "justice" as it gets lived: by men, in the first pages, by women in later pages, and throughout the volume, by families—since those who are called to pay (through time spent) for their transgressions come from homes, have wives and husbands, have children, have had parents and other relatives, and now have friends and neighbors as well. Through ties of kin, and life's chance meetings and involvements, we all belong to our particular islands. The waves of justice administered—handed down —come crashing mightily on those many shores, as Tom Roma's bold exploratory navigation of mind and heart (given expression by his camera) amply shows and invites us to ponder, with a moral seriousness worthy of the grave and solemn subject presented in these pages.

"In the halls of justice, the only justice is in the halls."

— Lenny Bruce

PART ONE

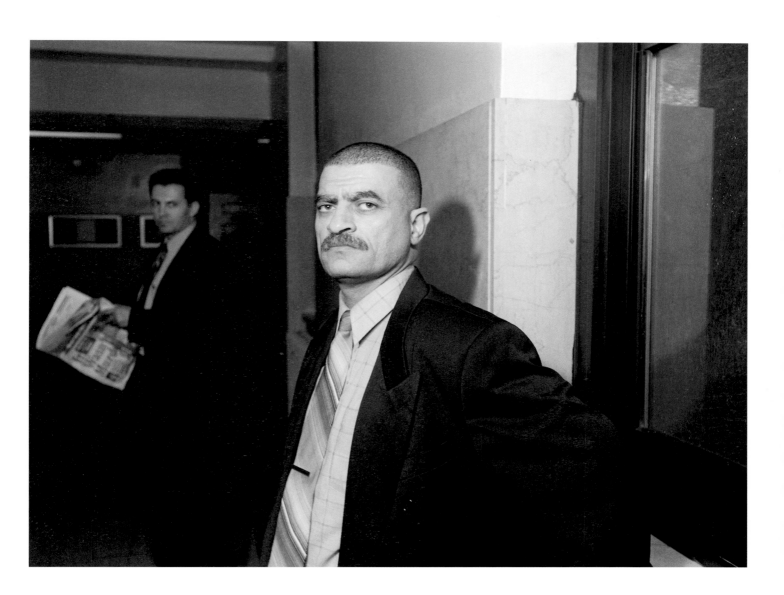

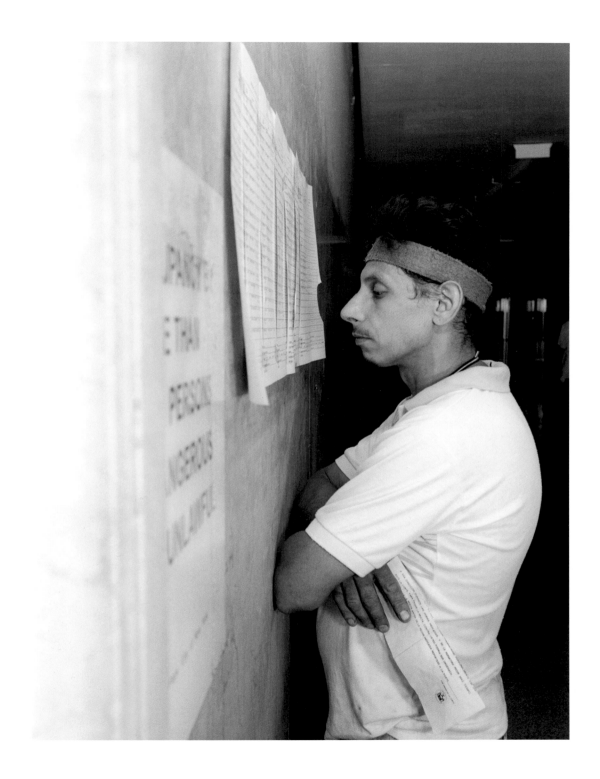

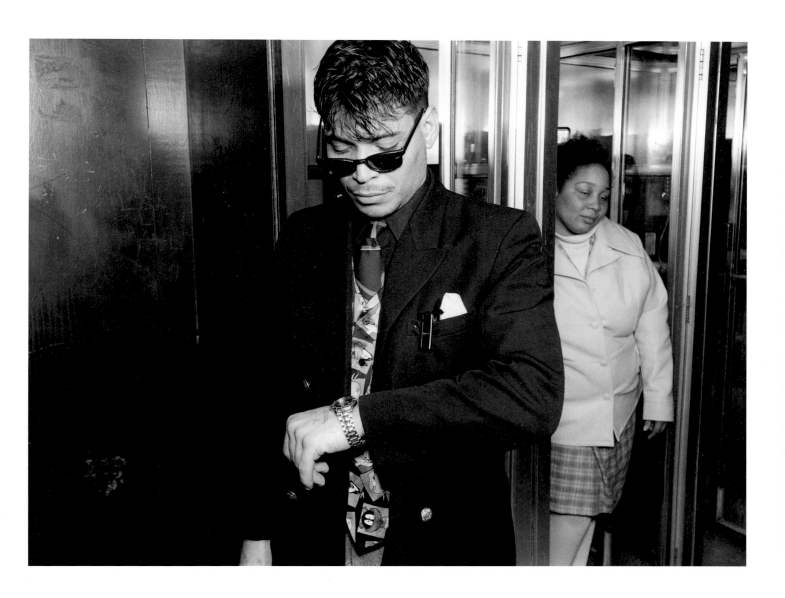

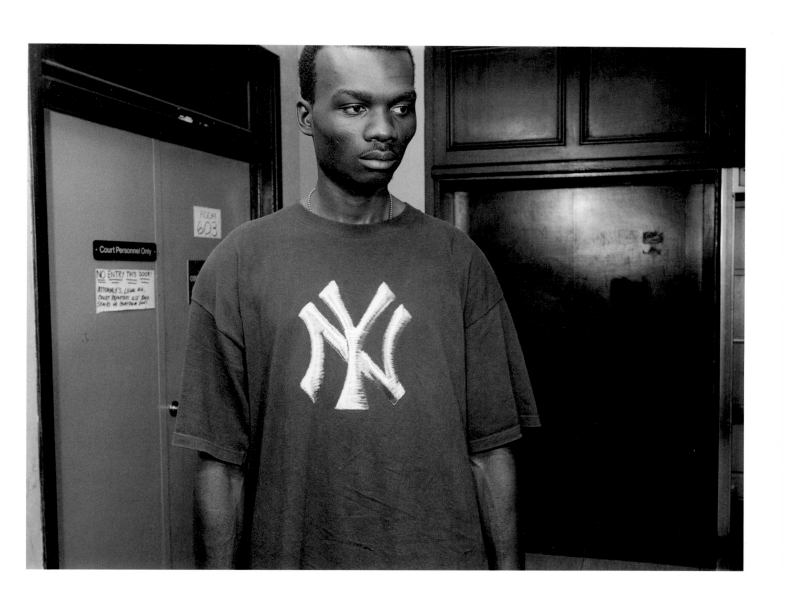

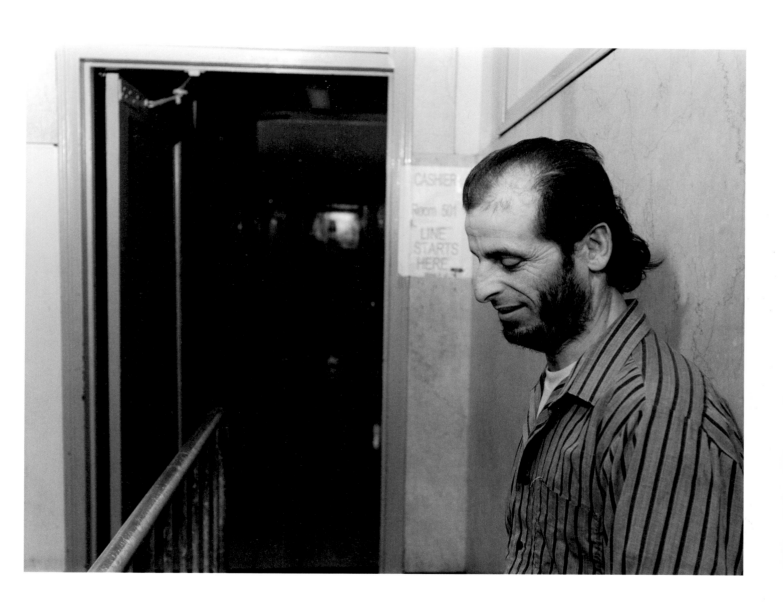

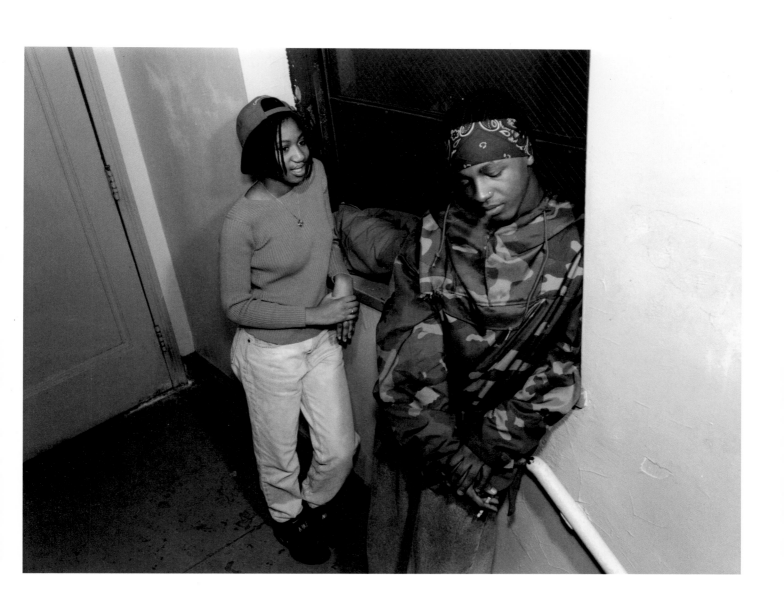

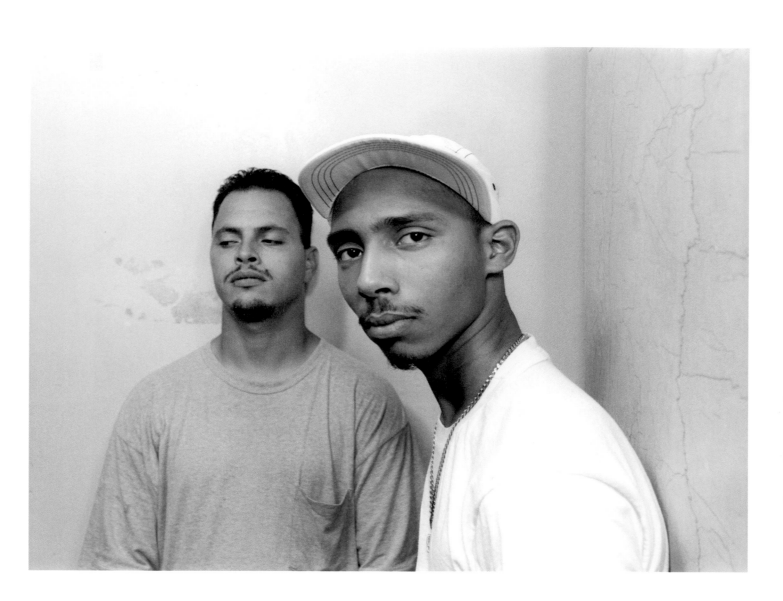

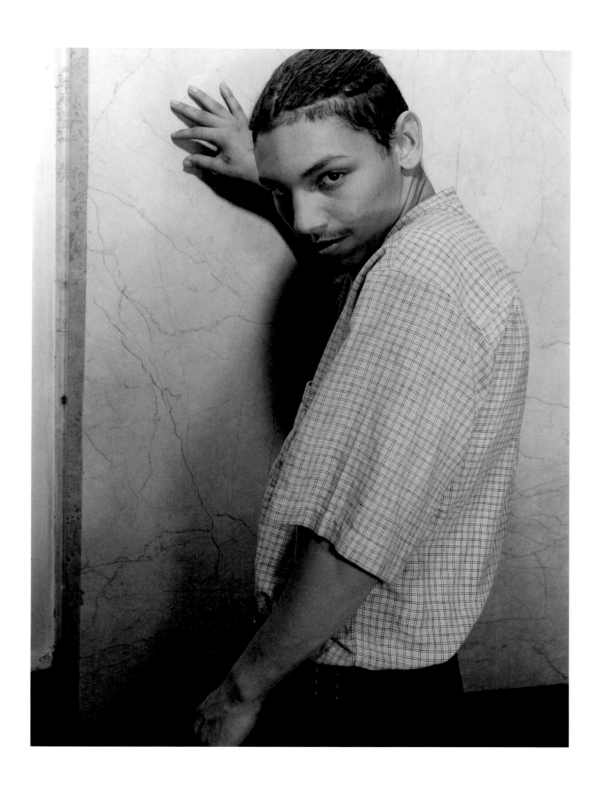

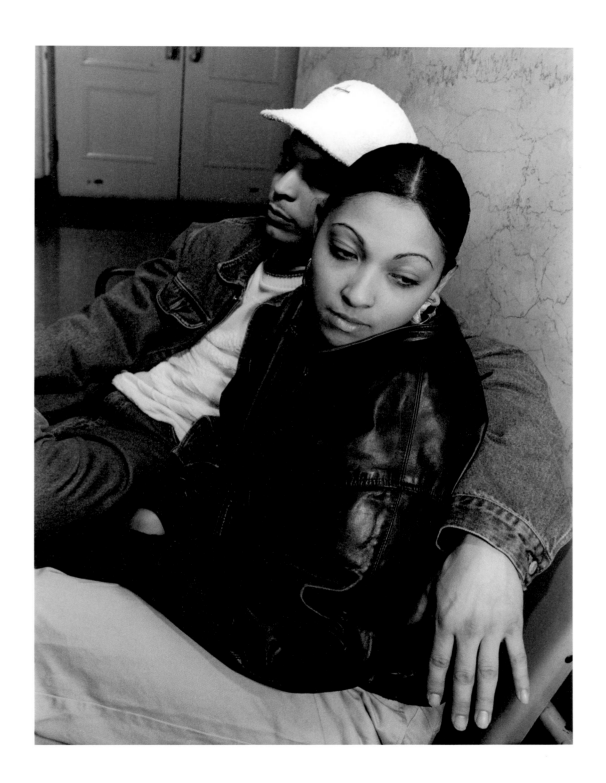

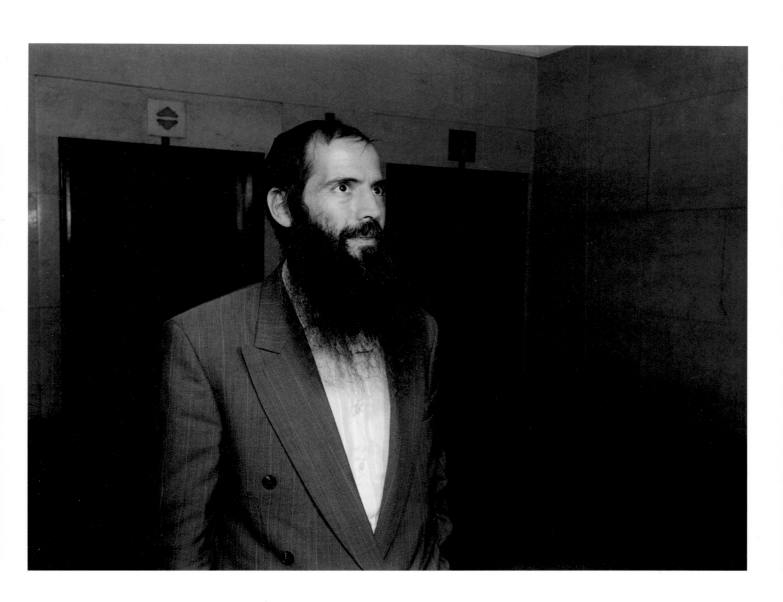

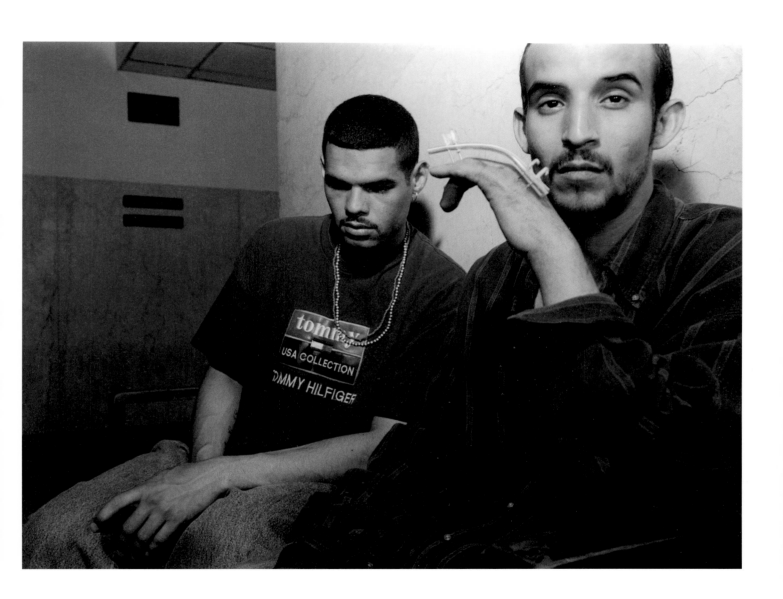

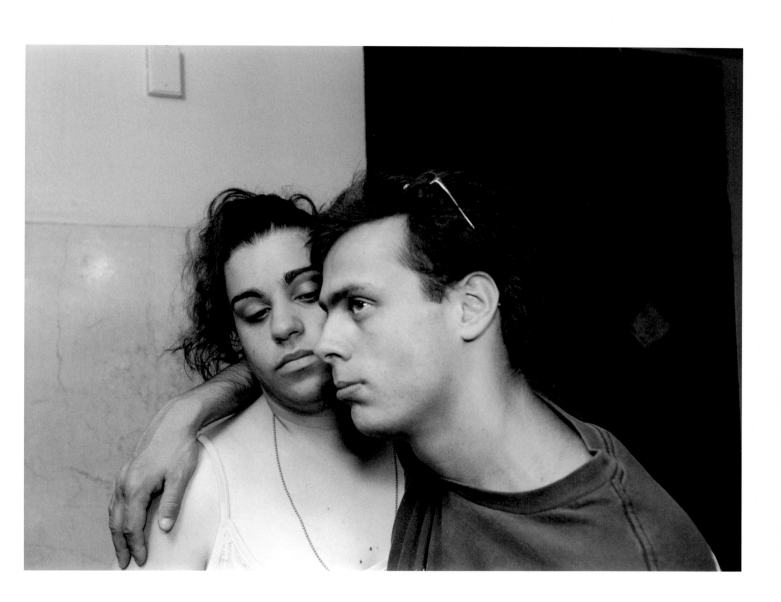

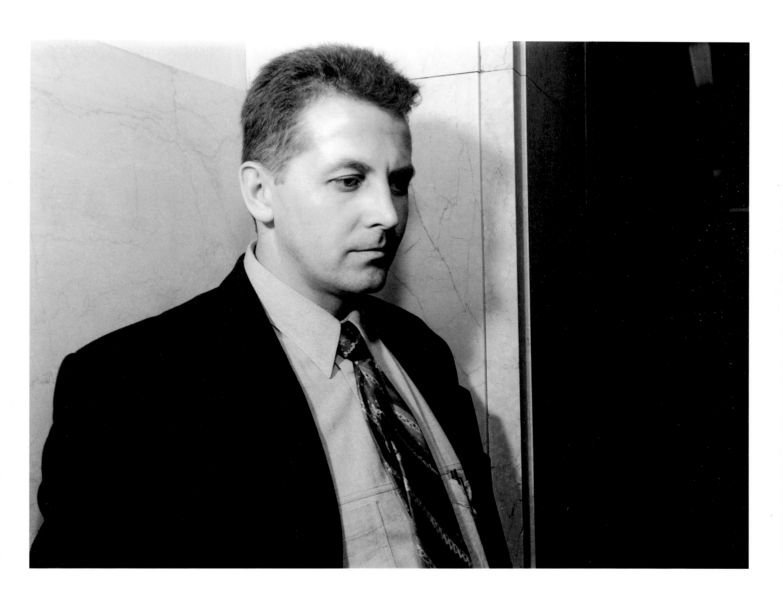

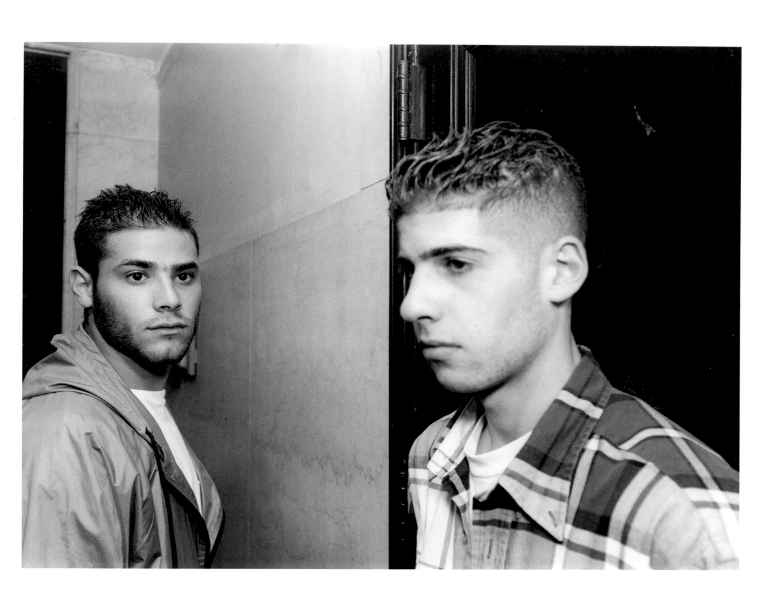

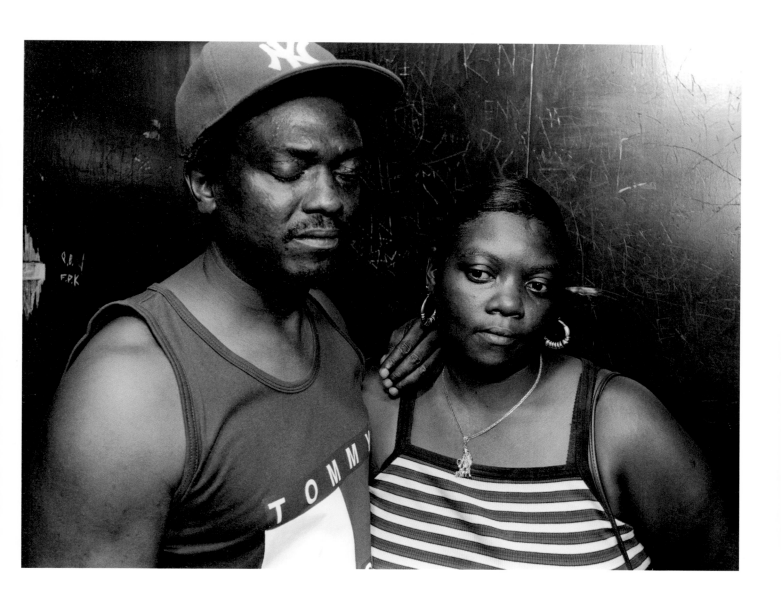

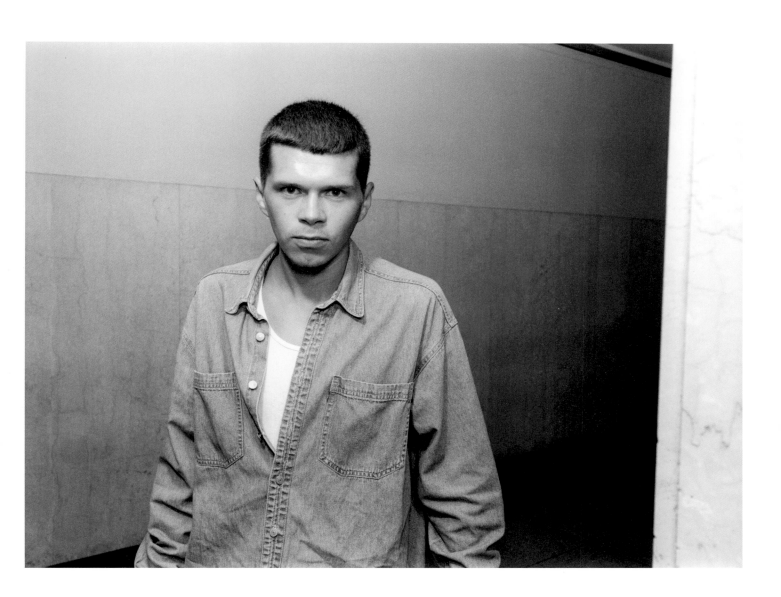

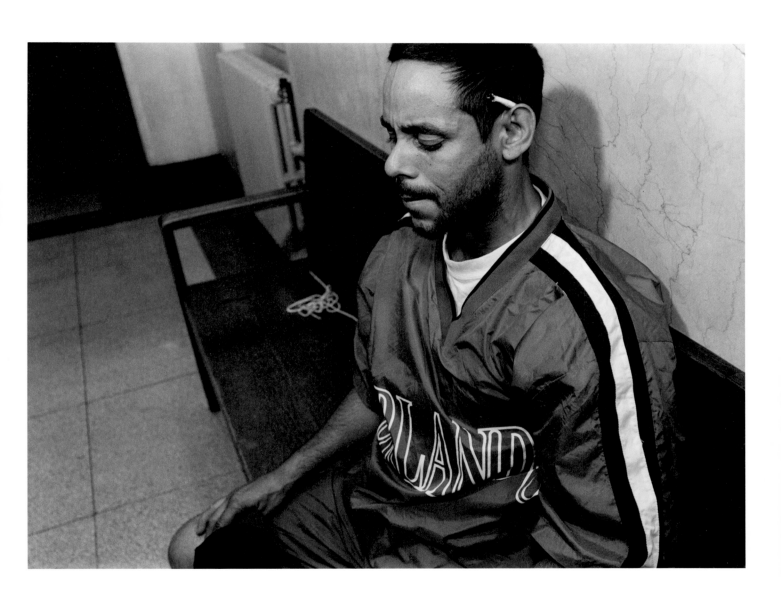

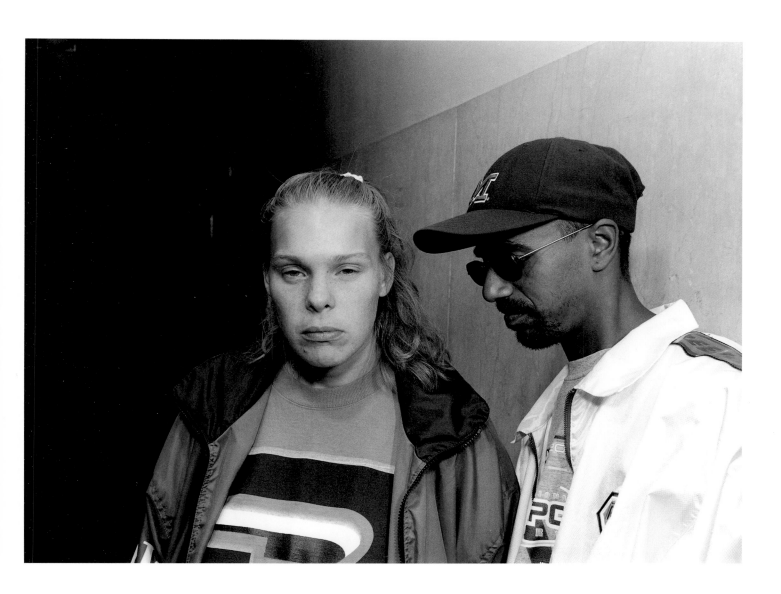

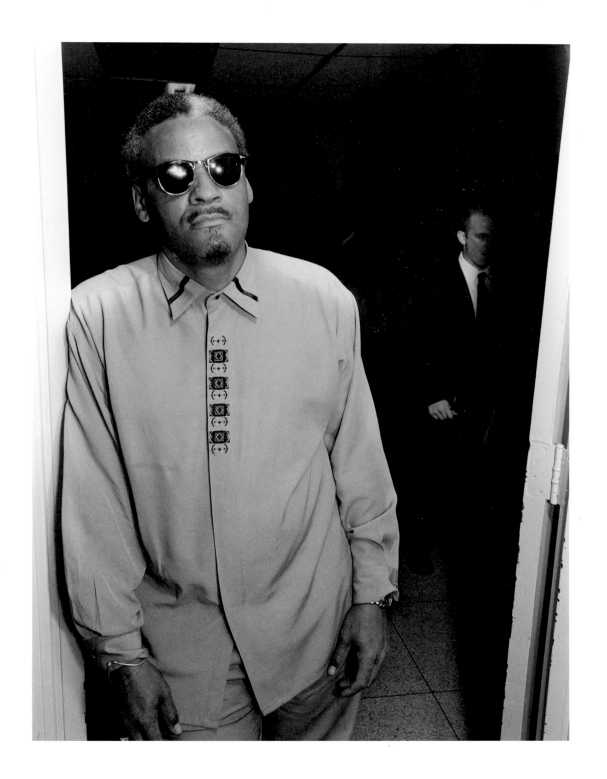

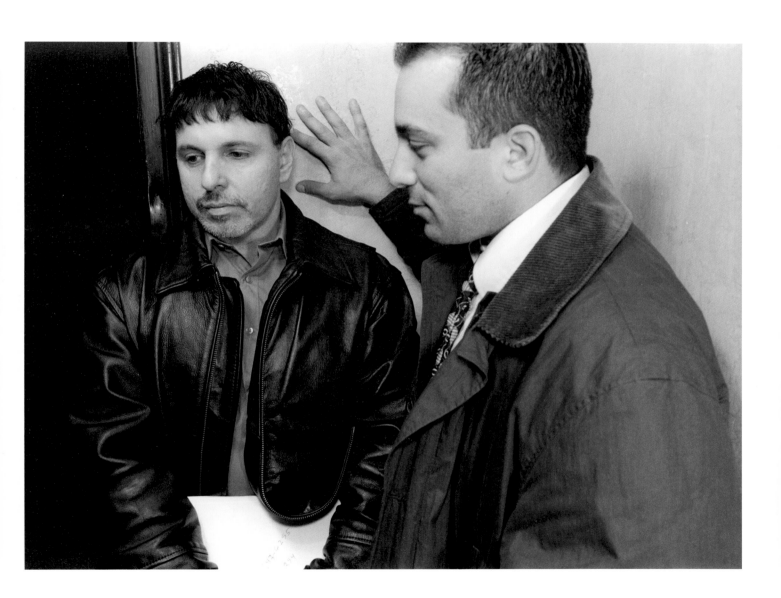

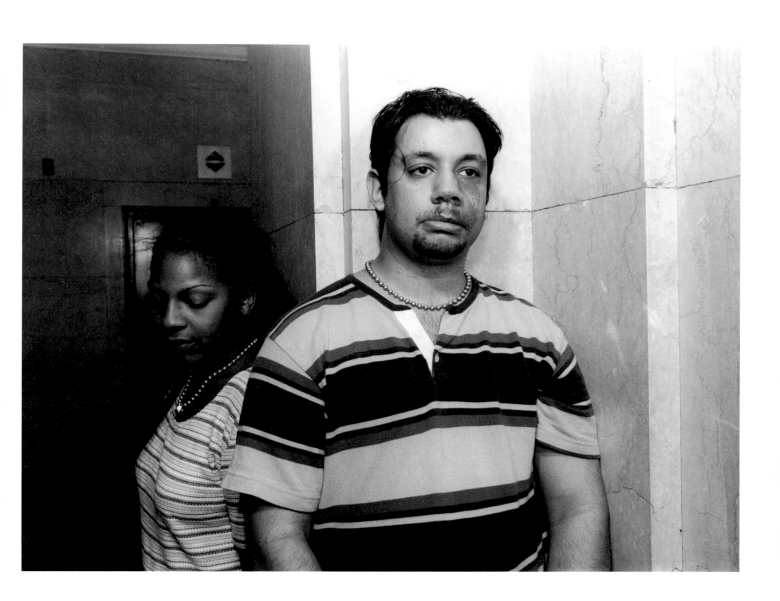

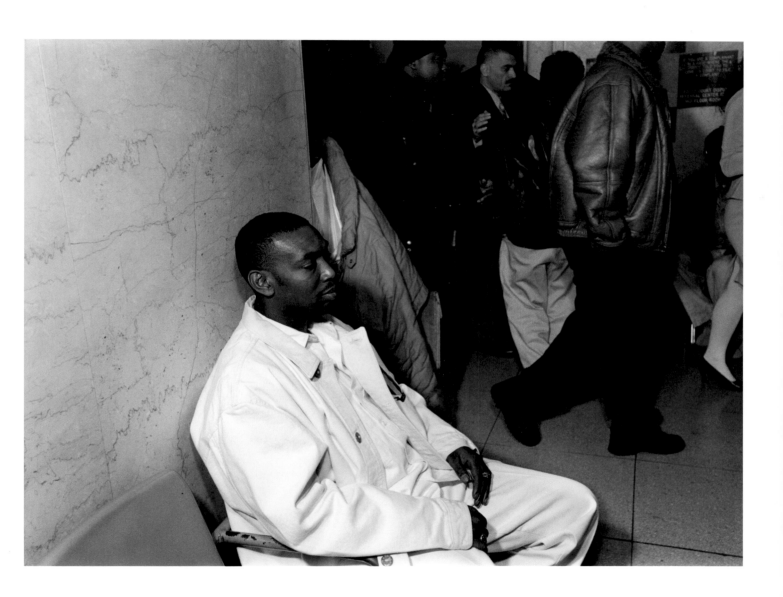

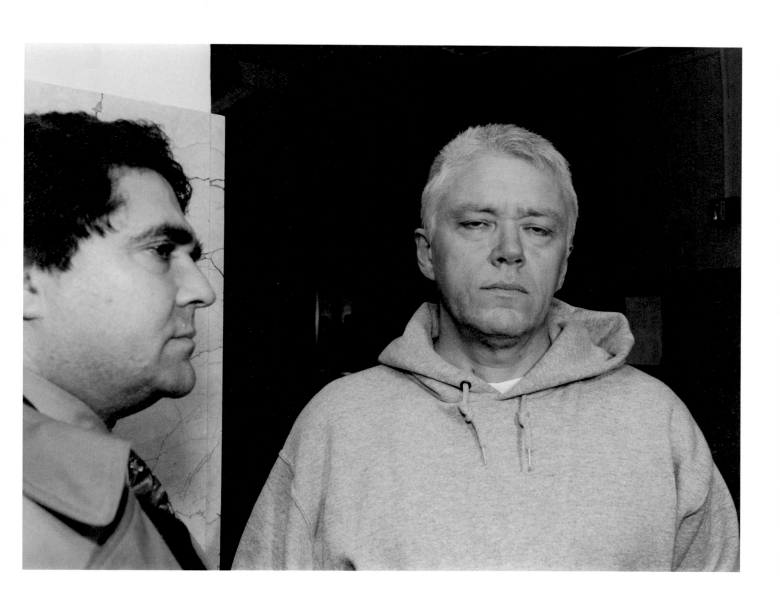

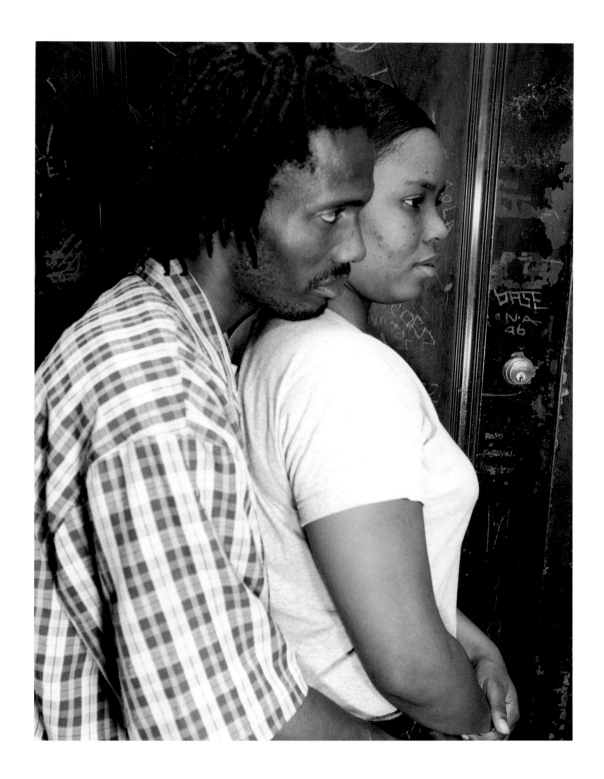

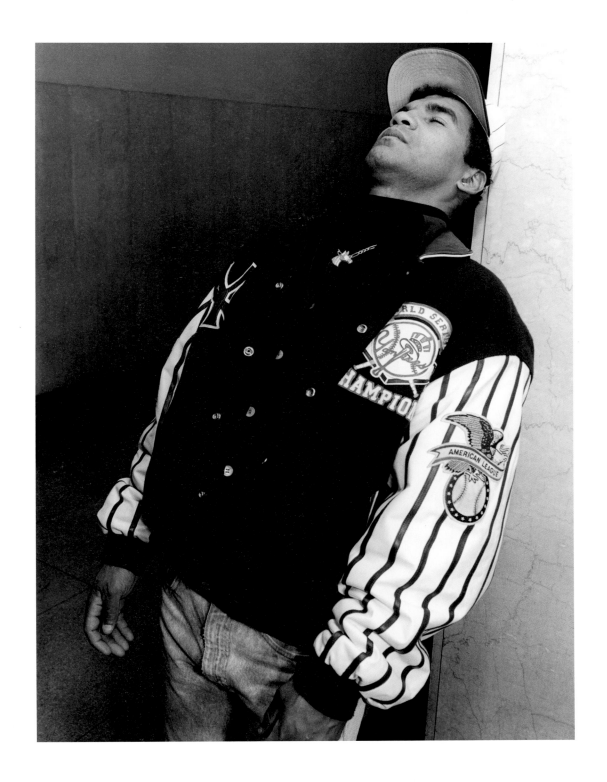

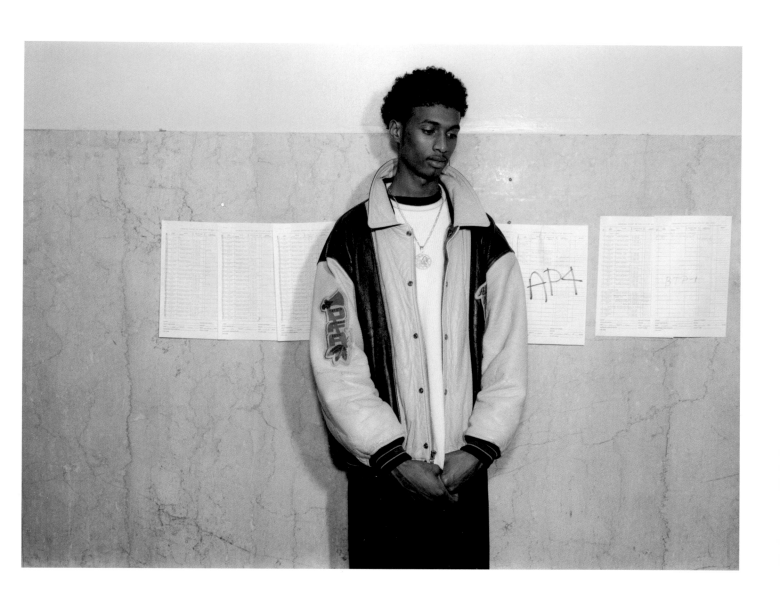

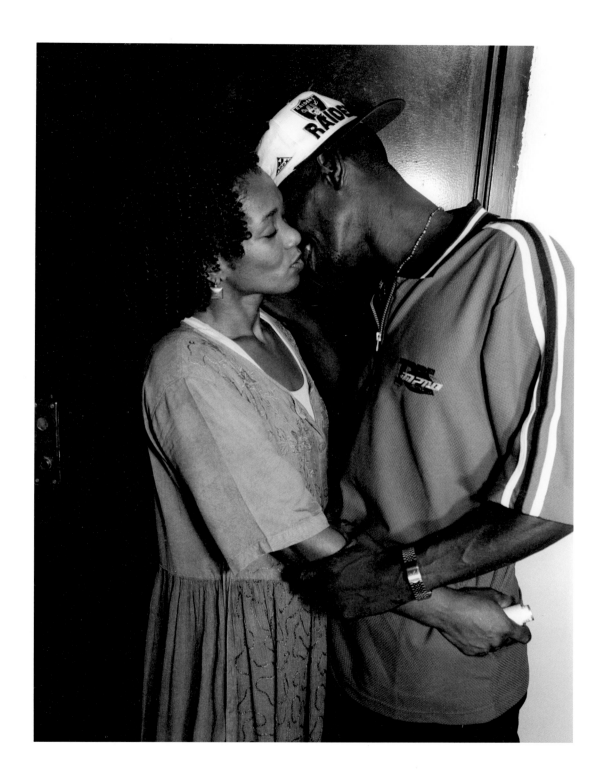

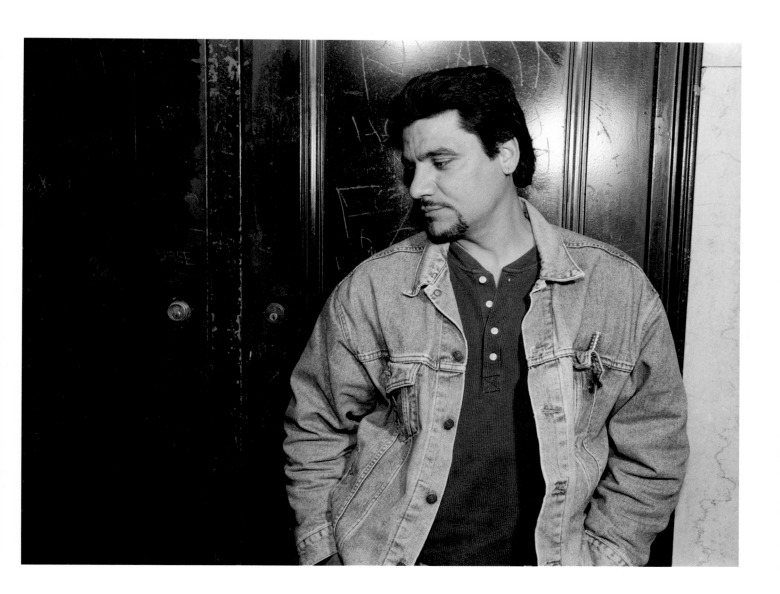

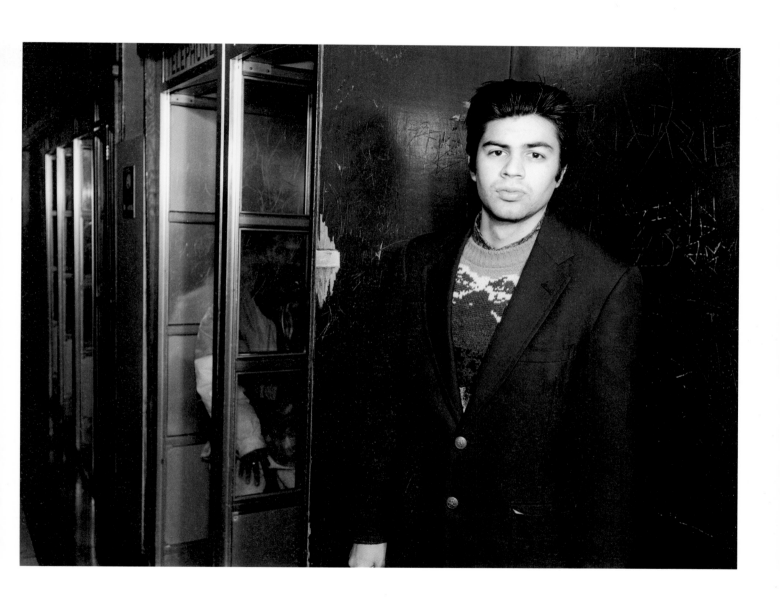

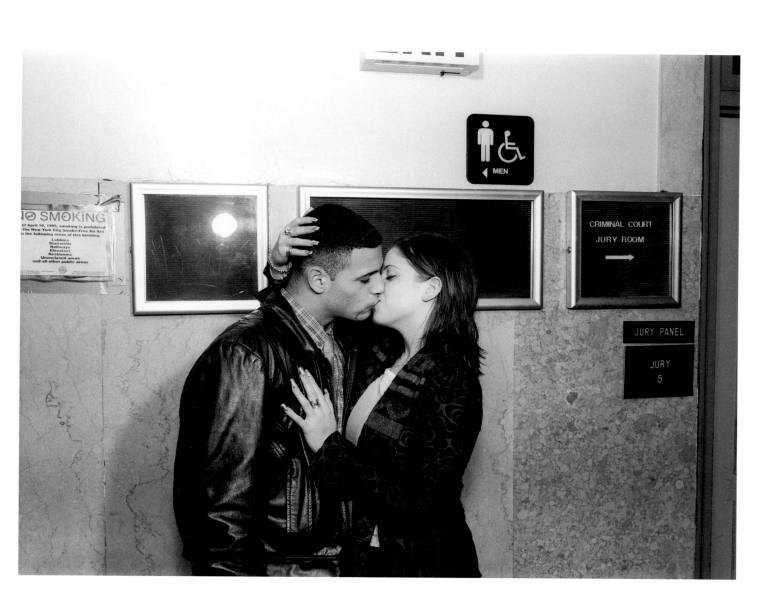

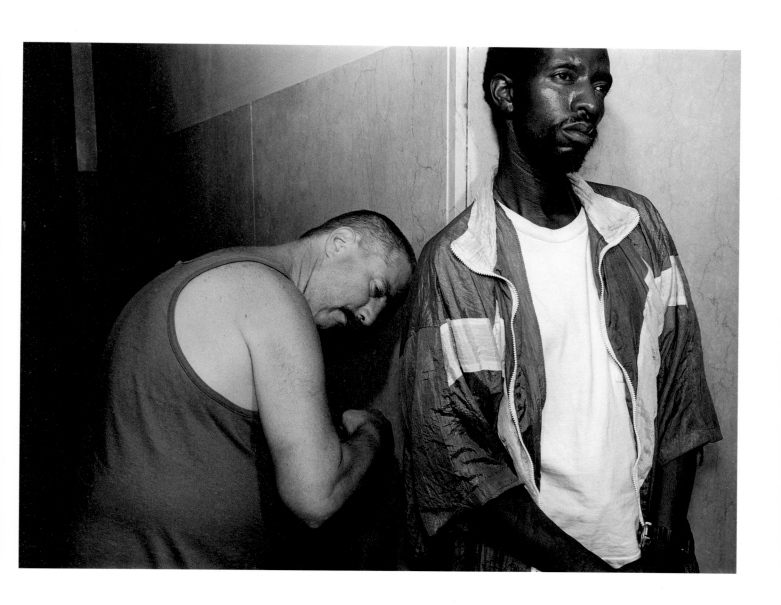

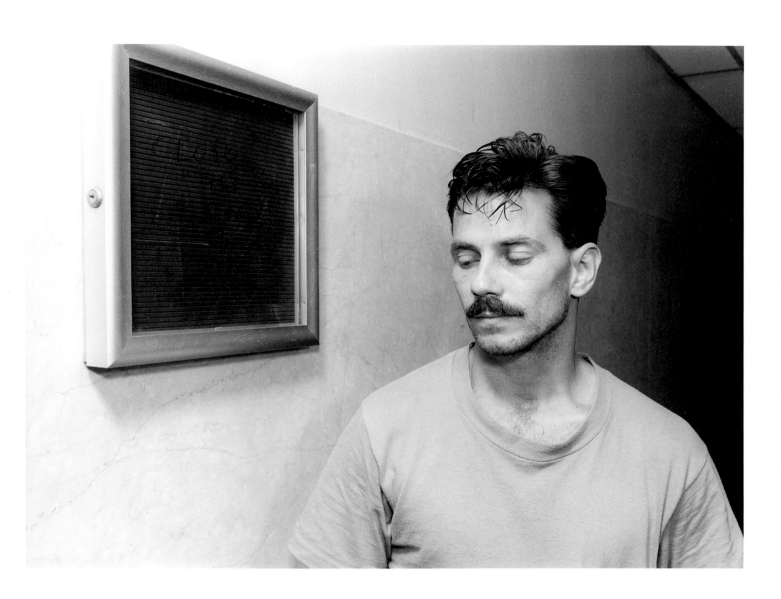

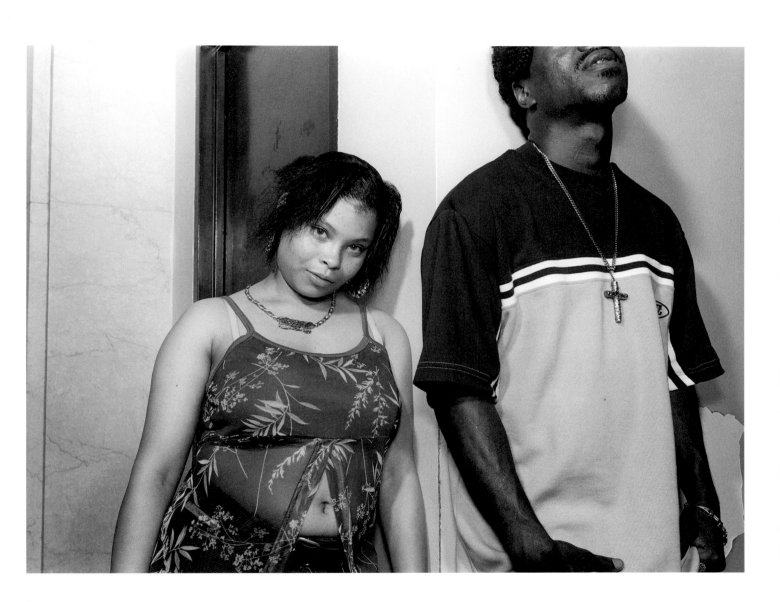

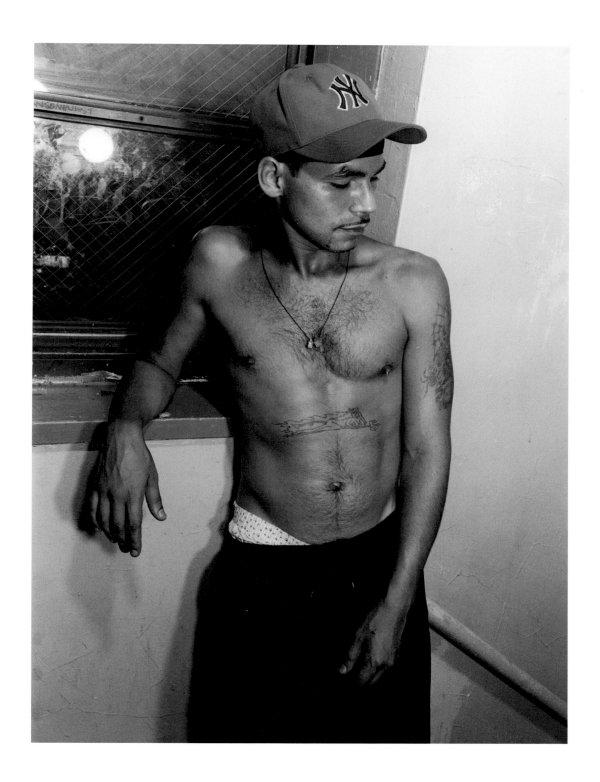

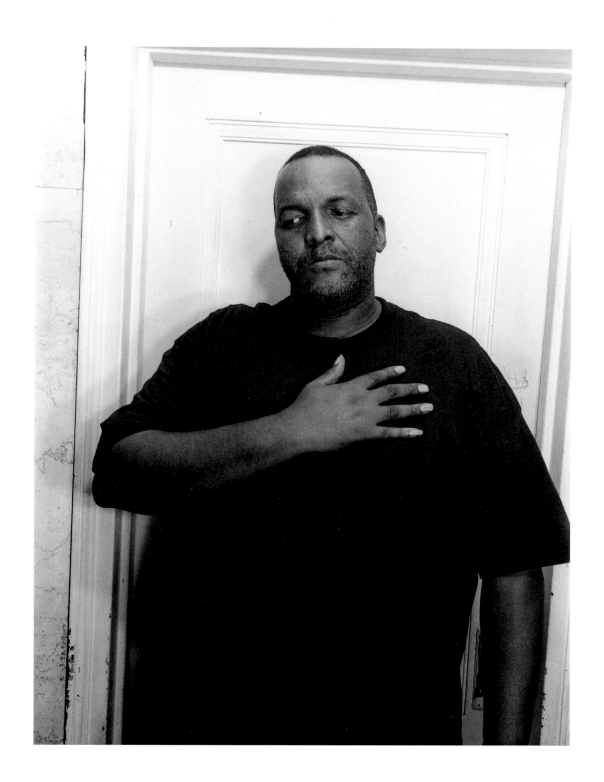

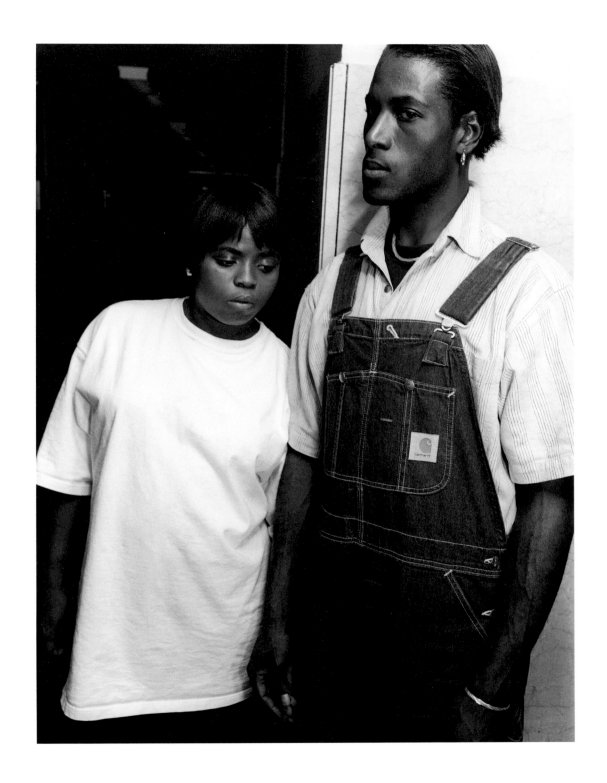

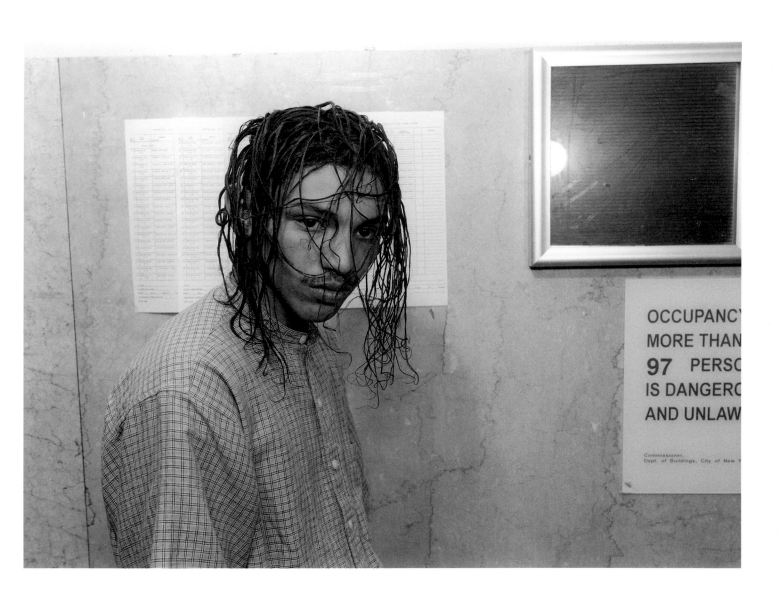

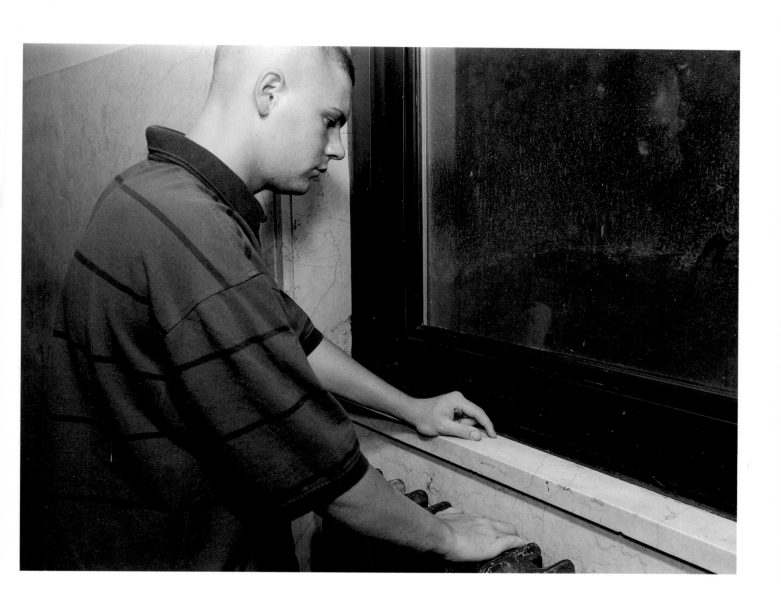

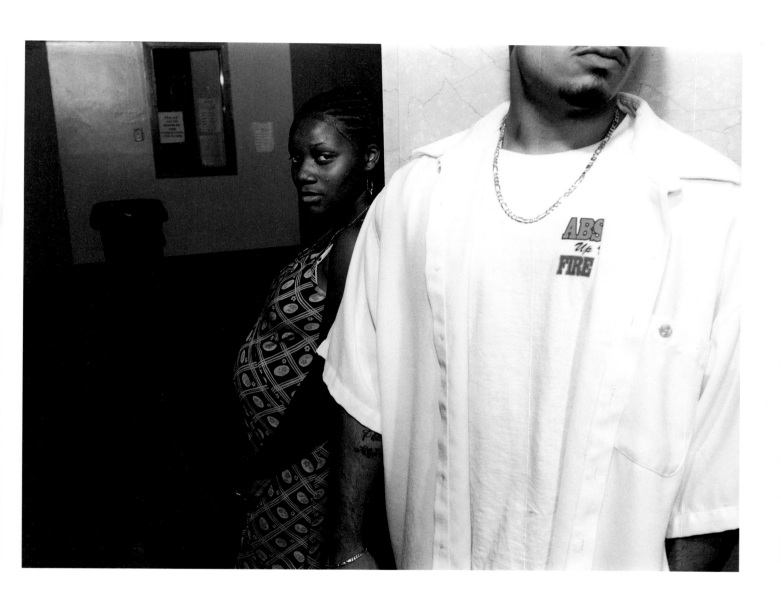

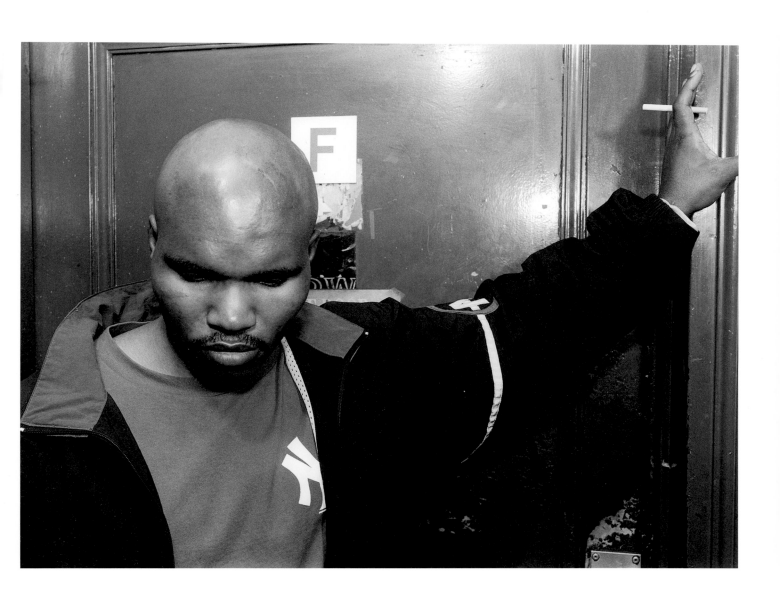

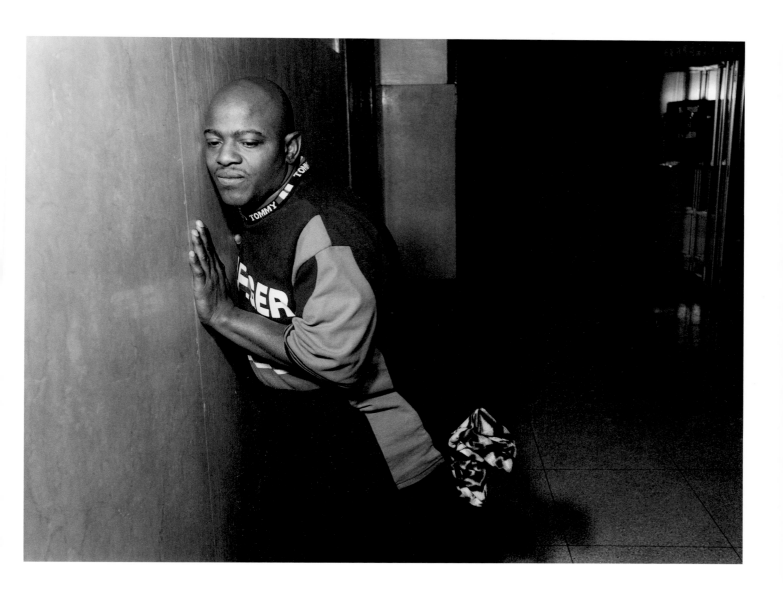

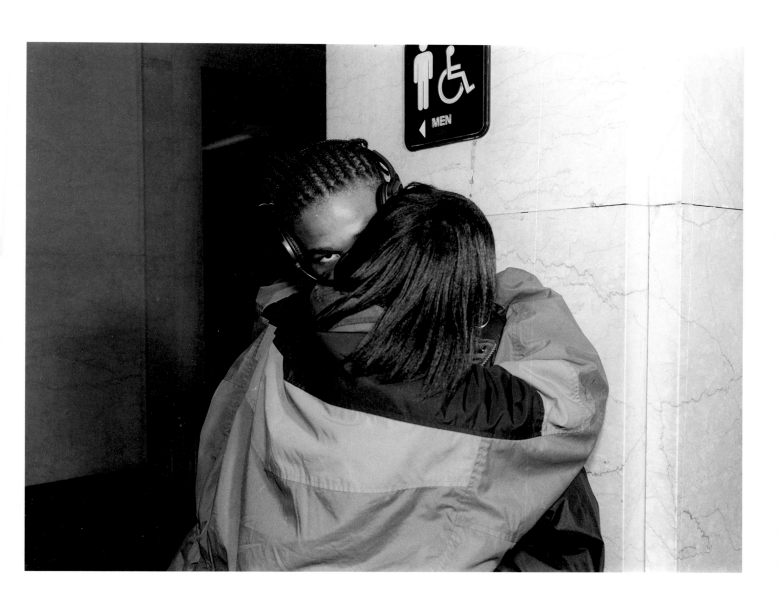

PART TWO

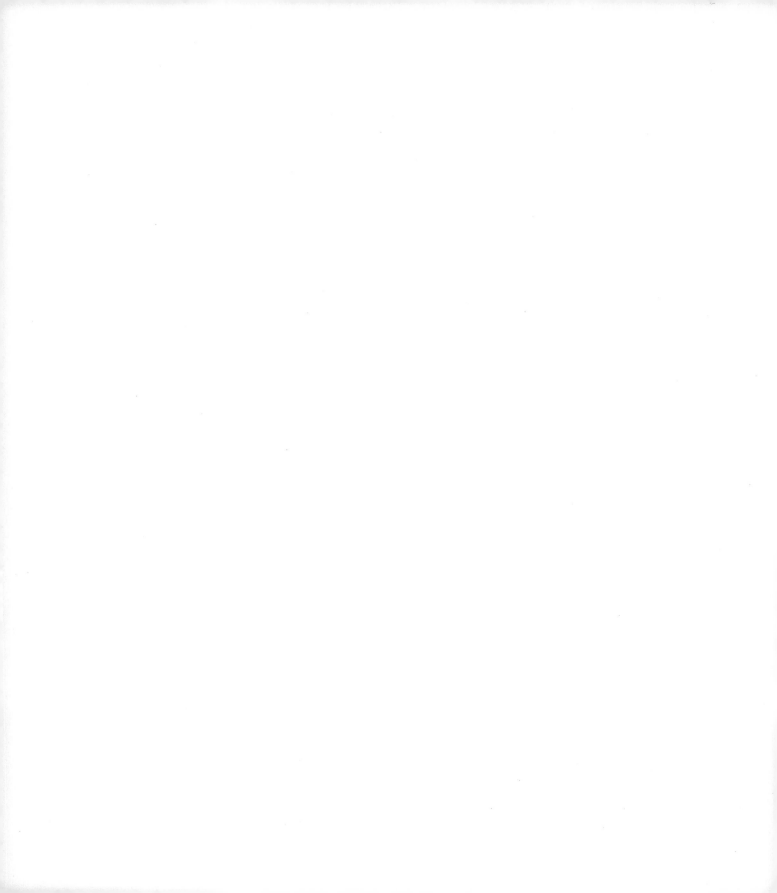

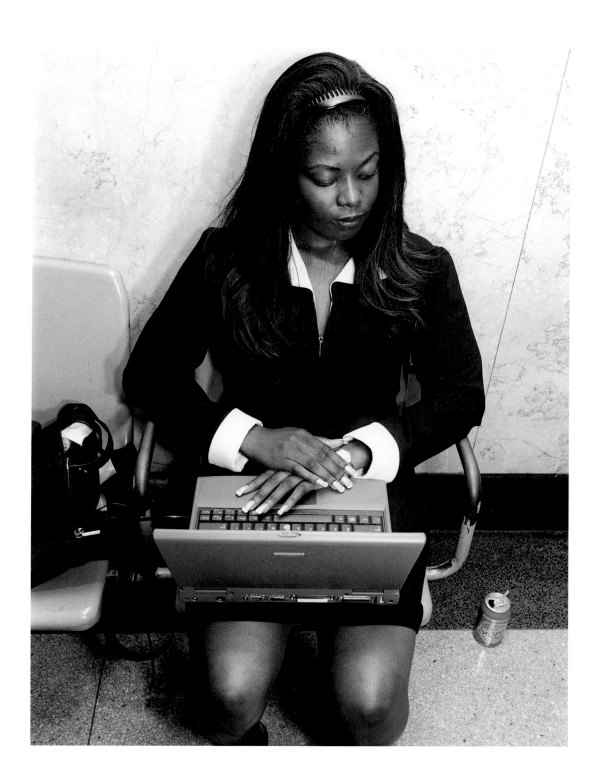

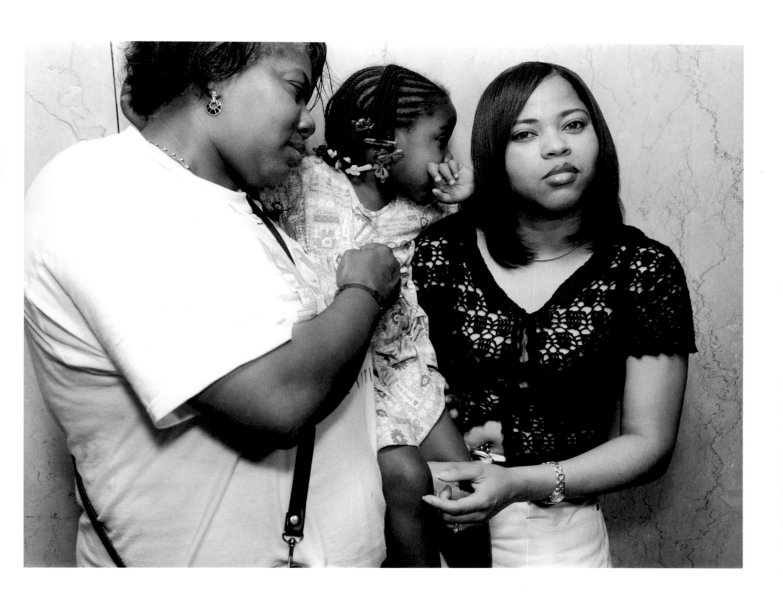

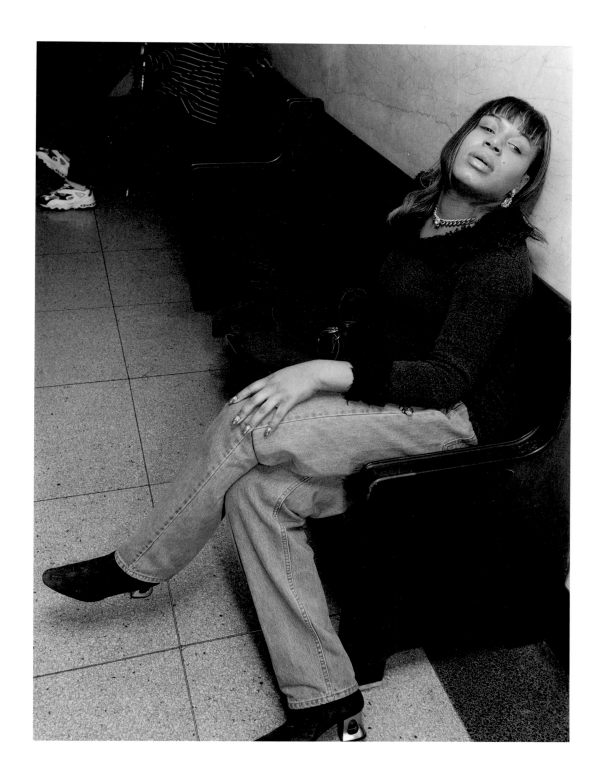

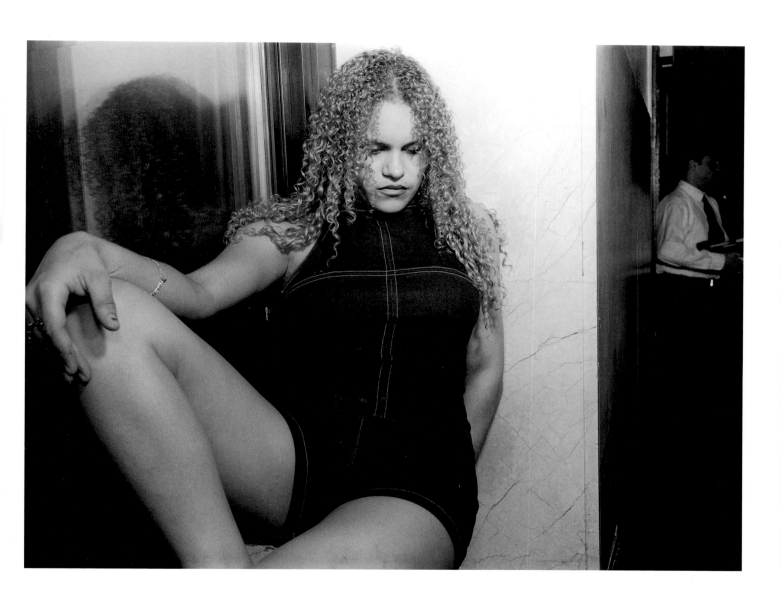

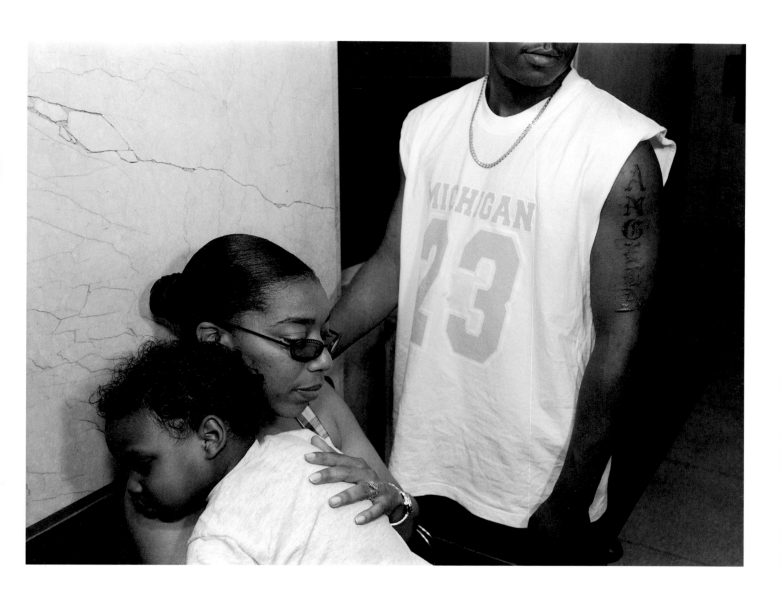

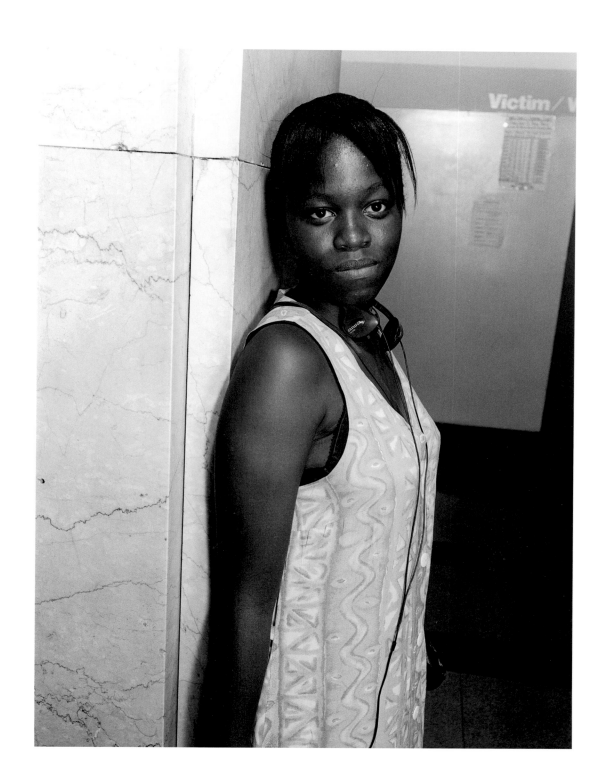

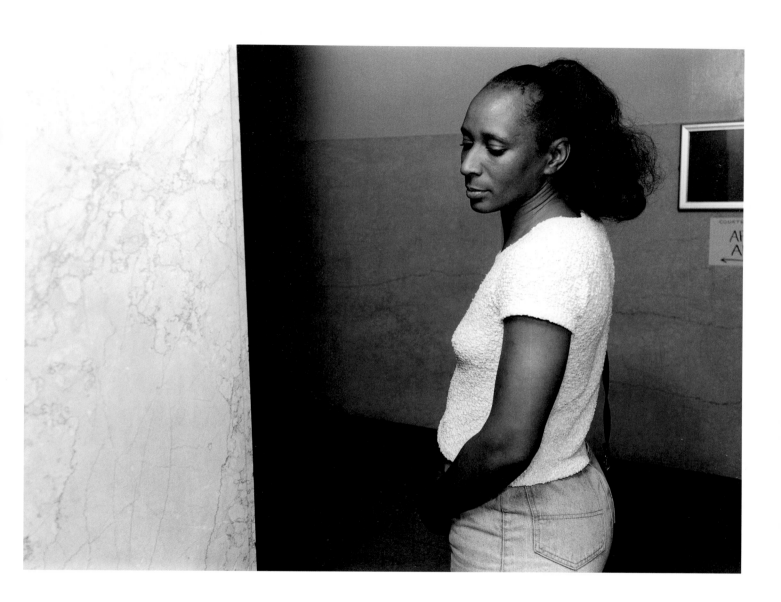

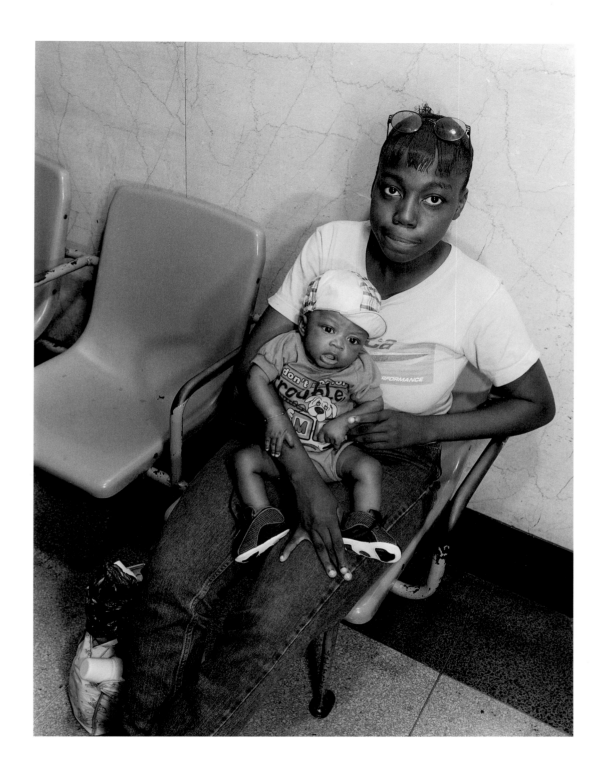

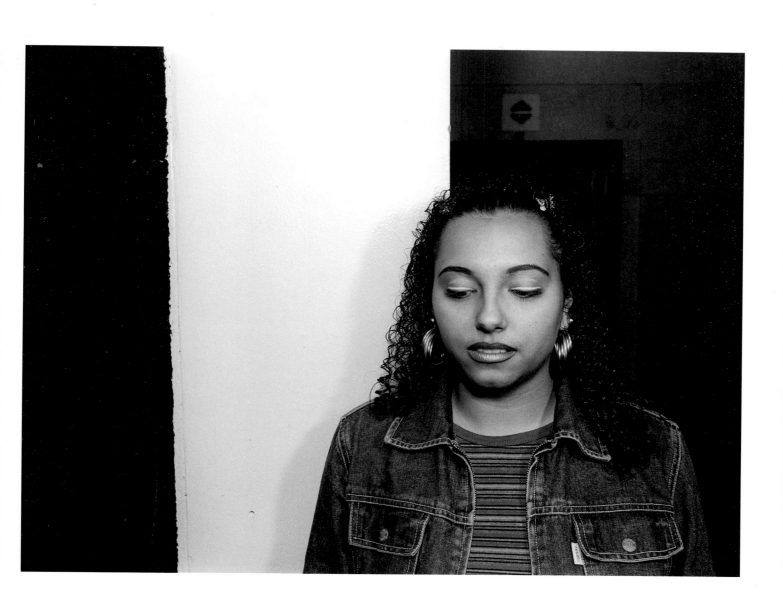

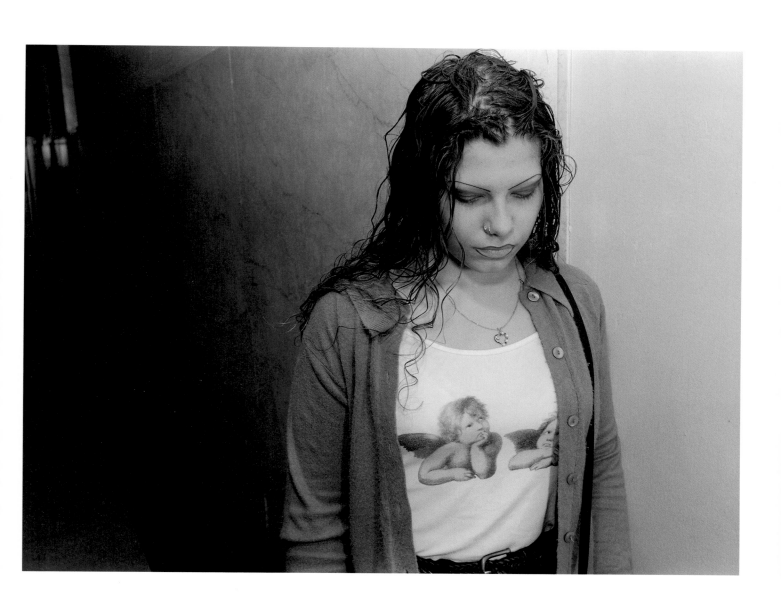

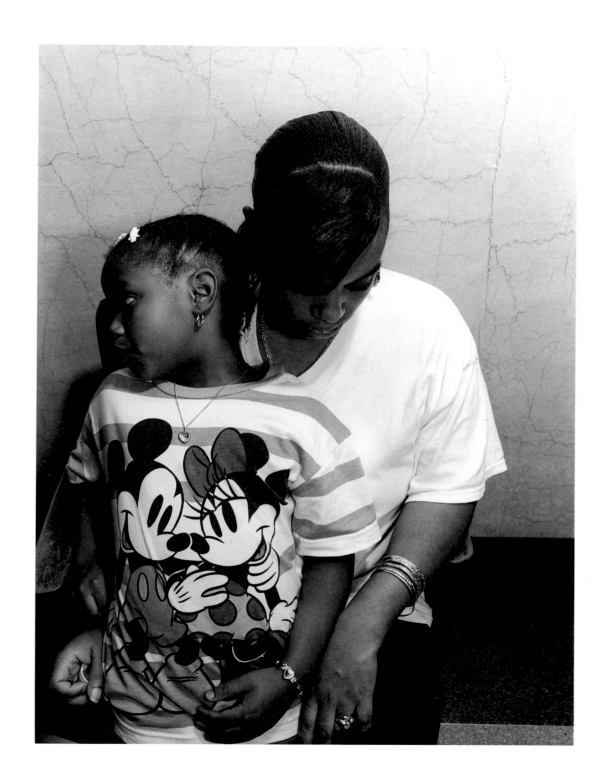

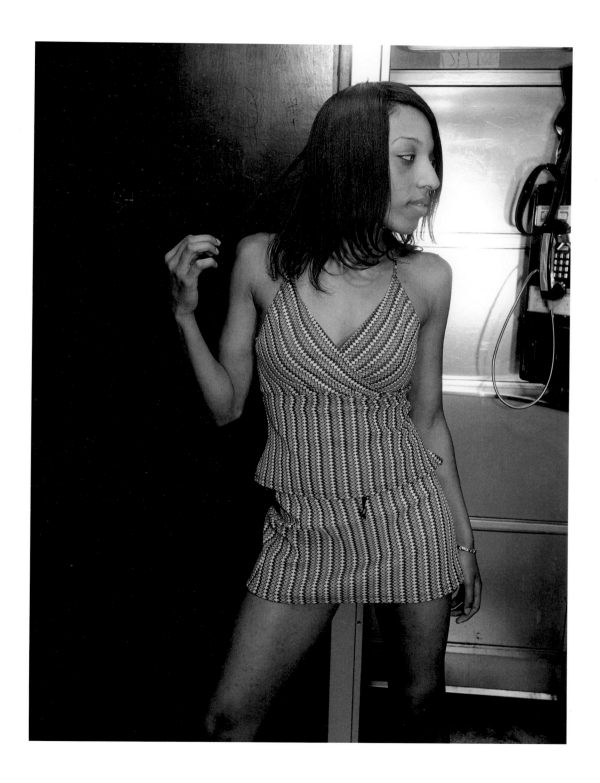

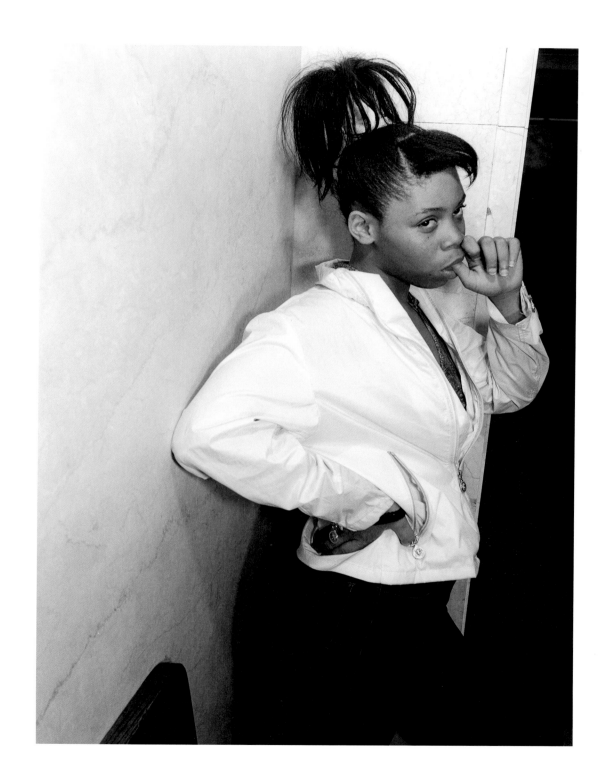

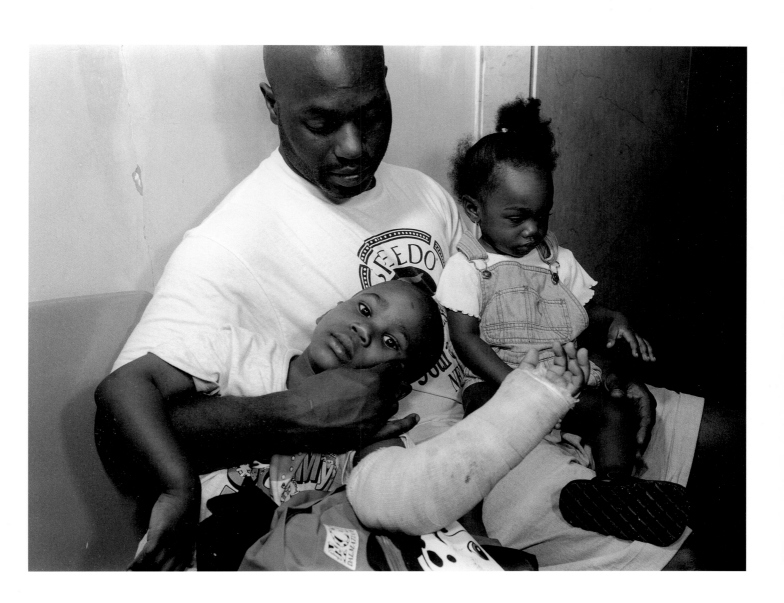

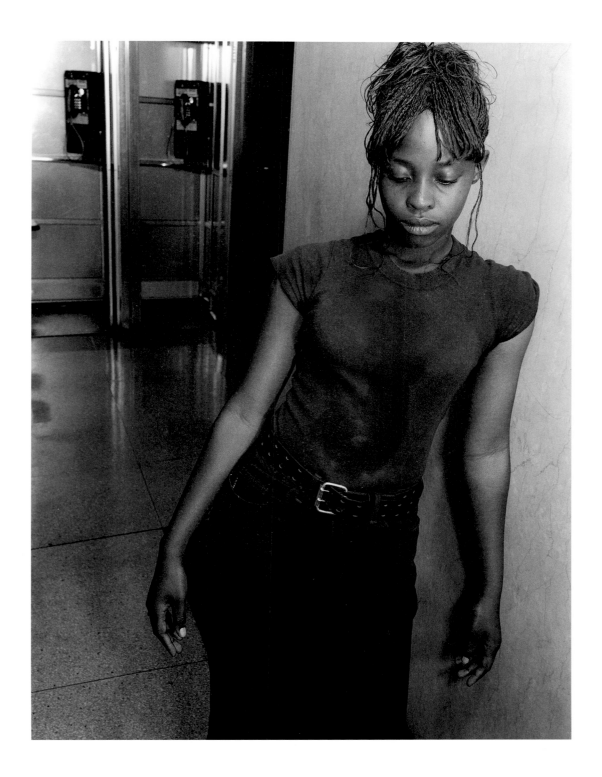

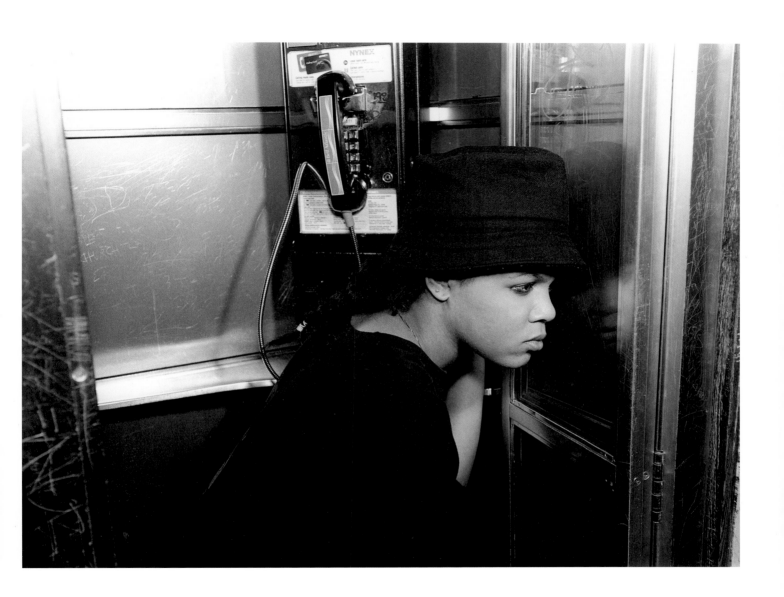

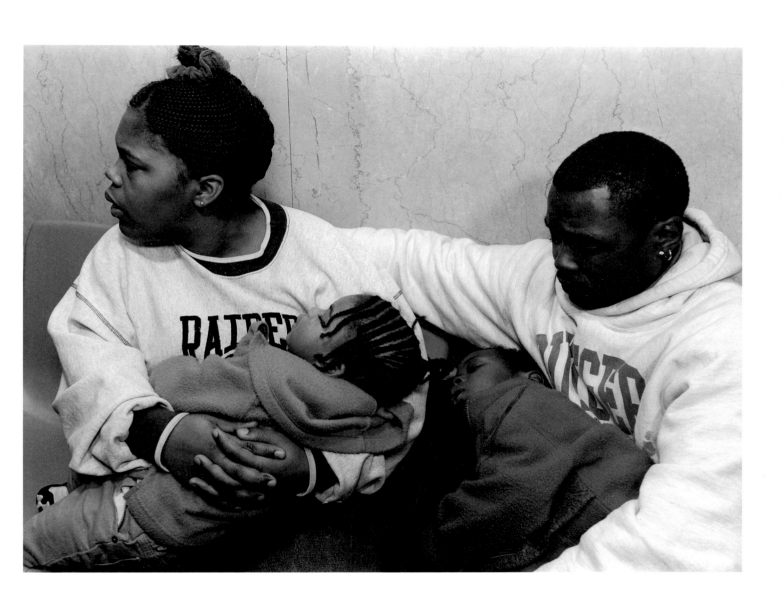

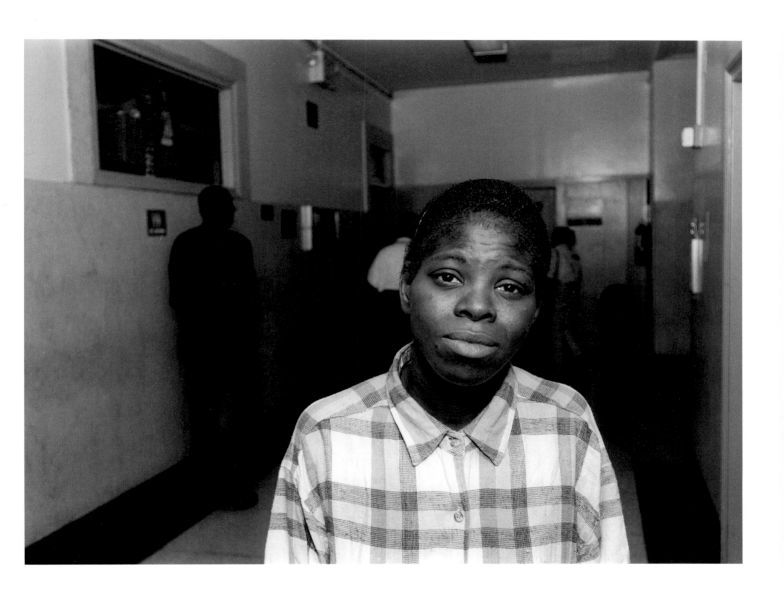

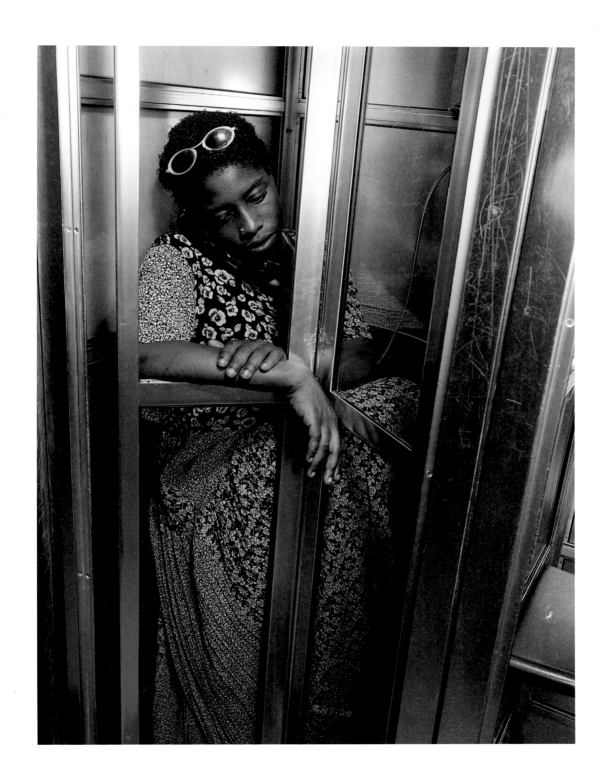

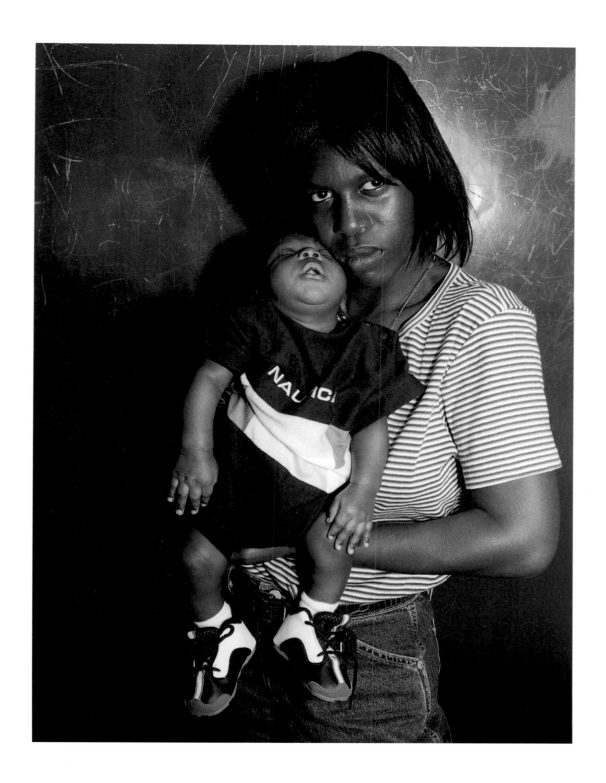

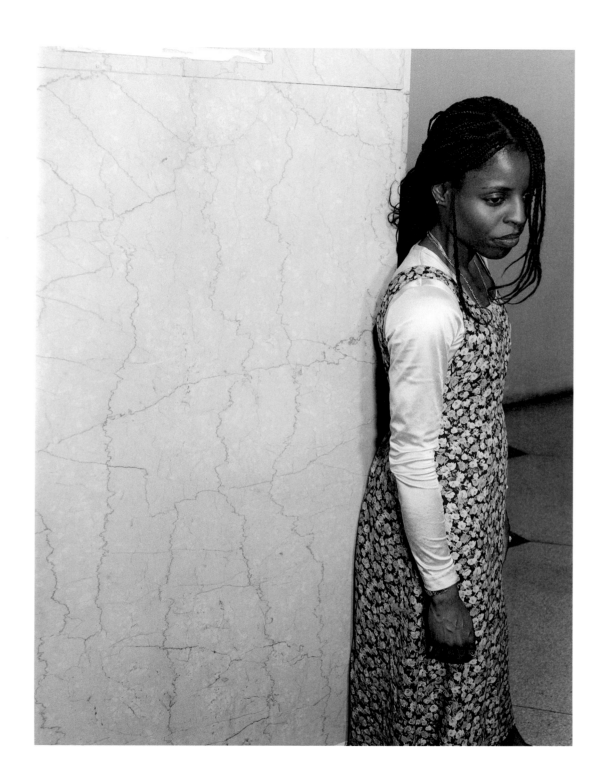

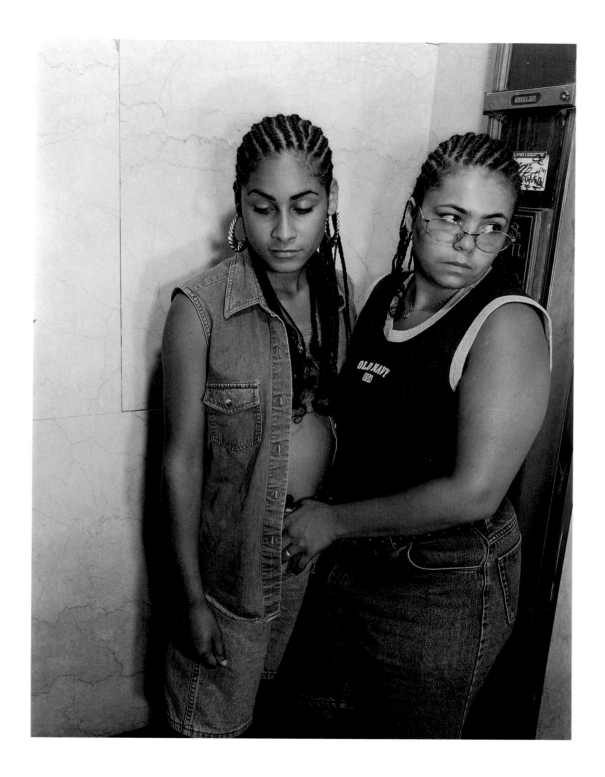

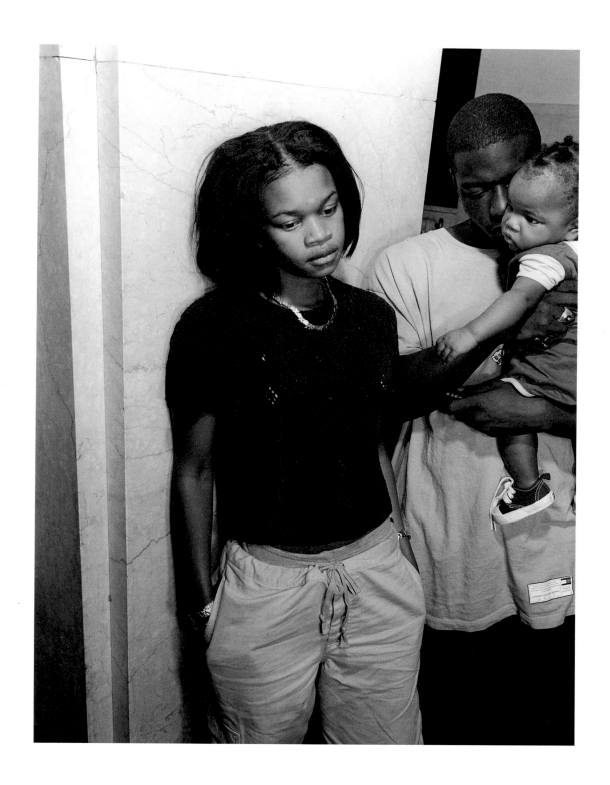

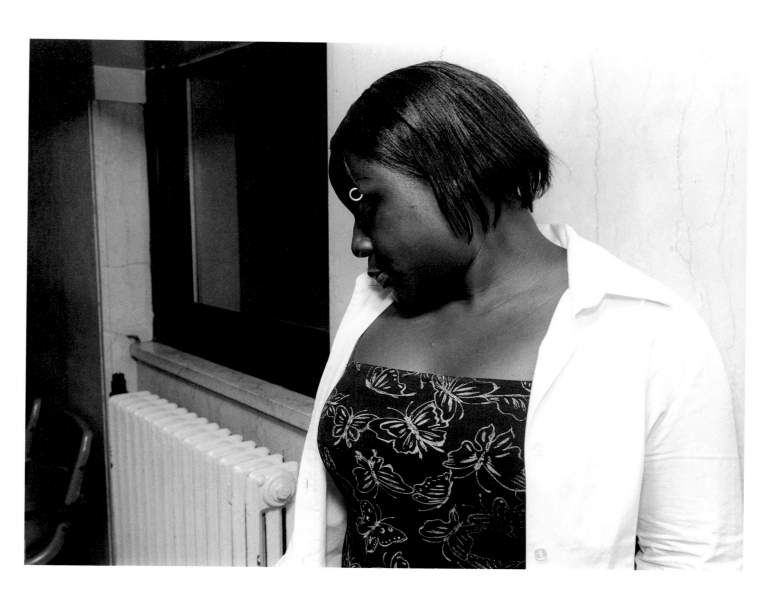

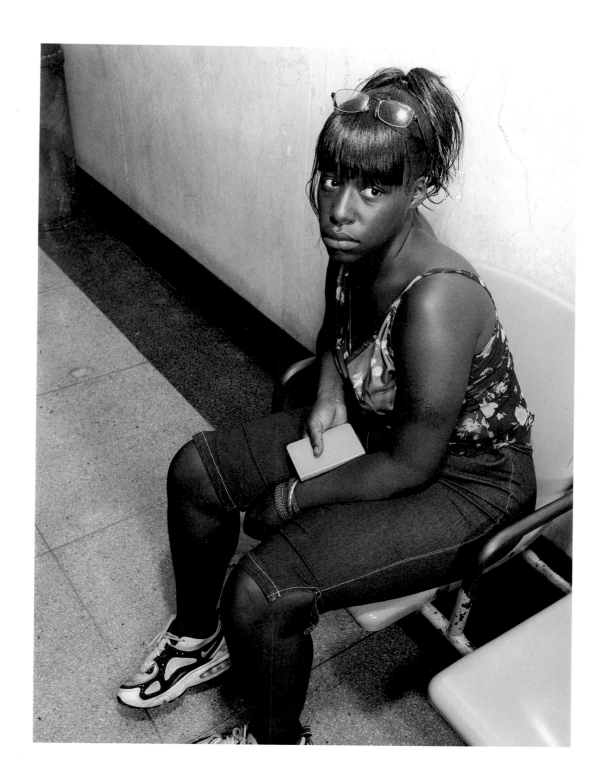

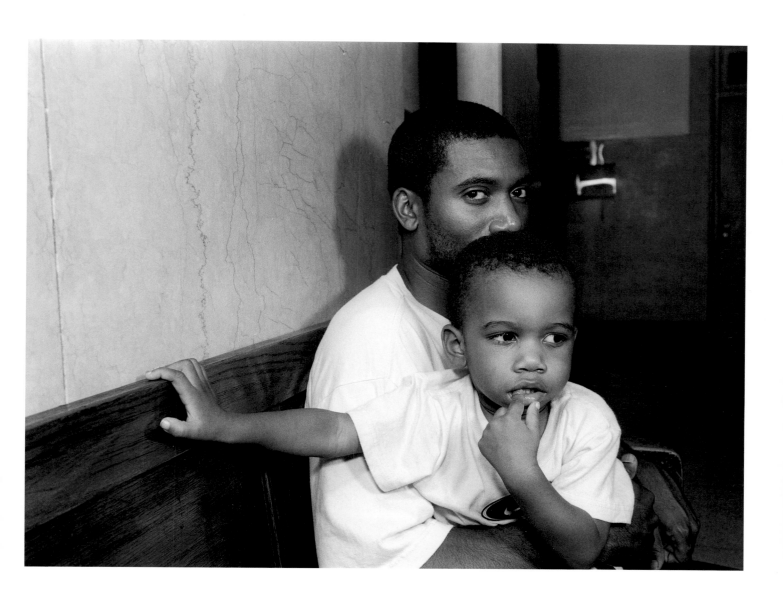

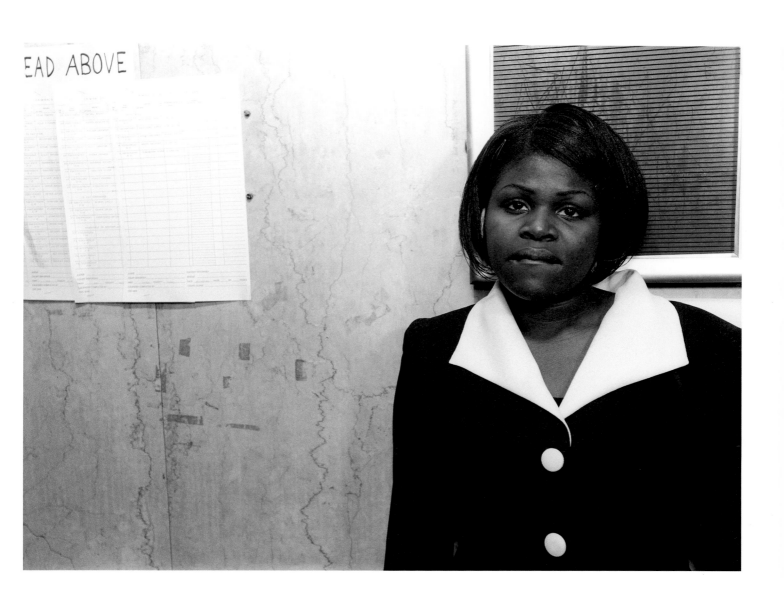

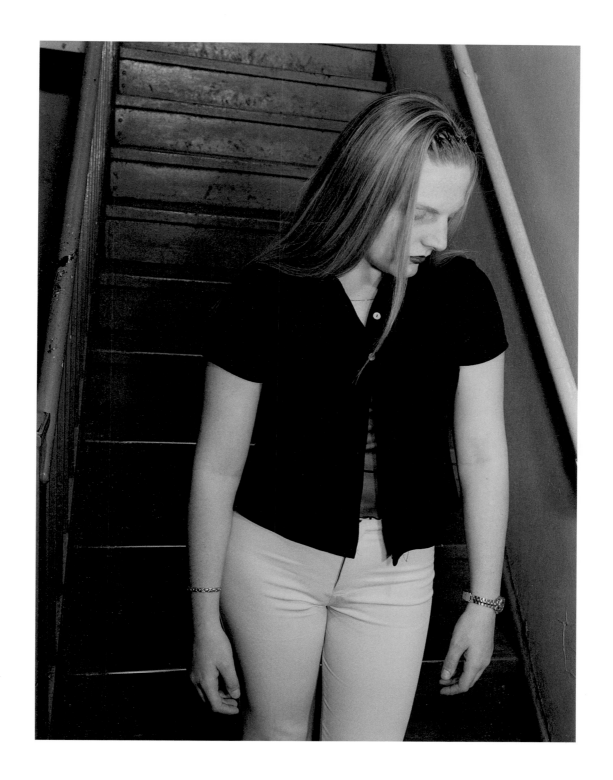

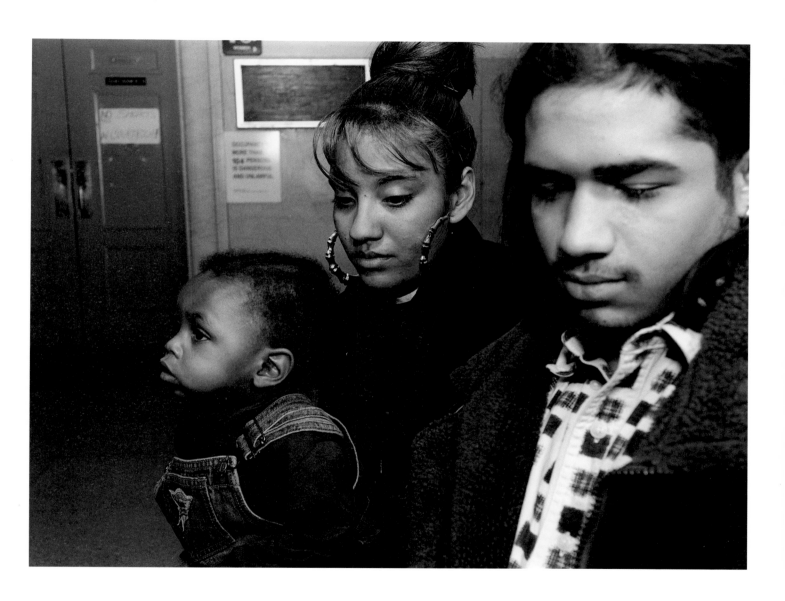

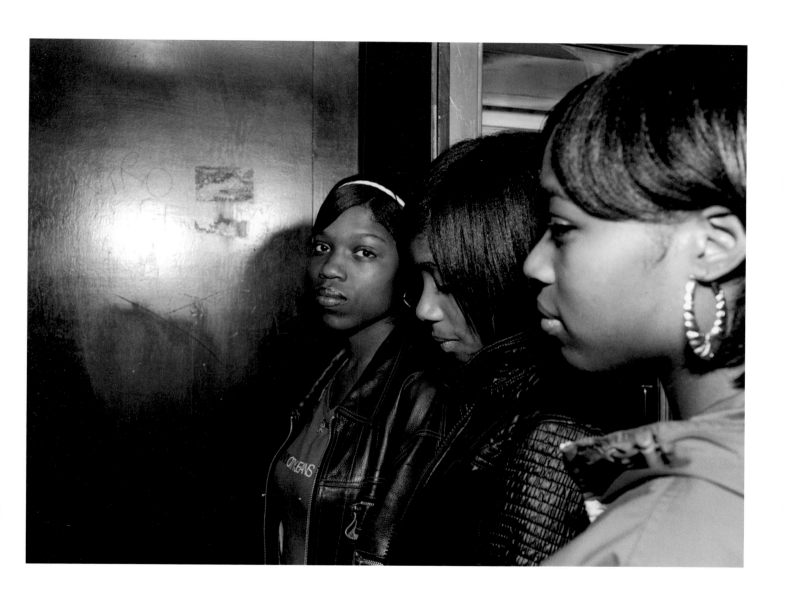

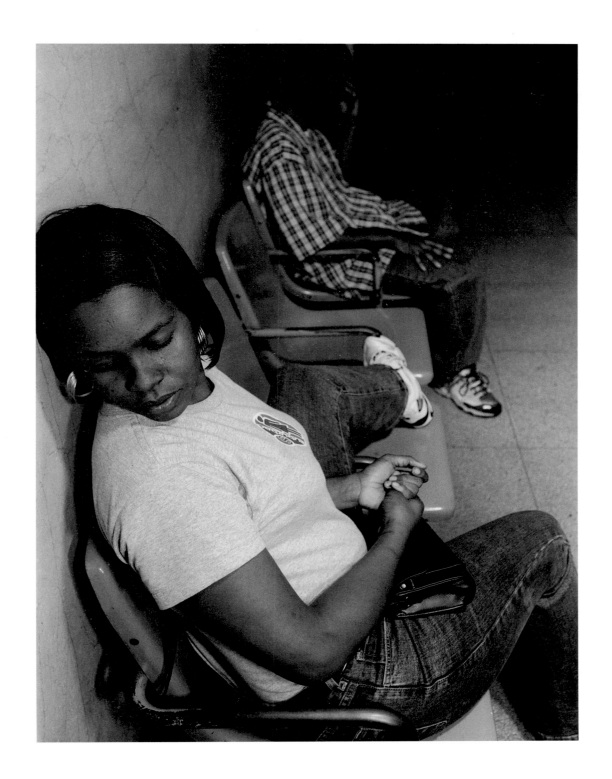

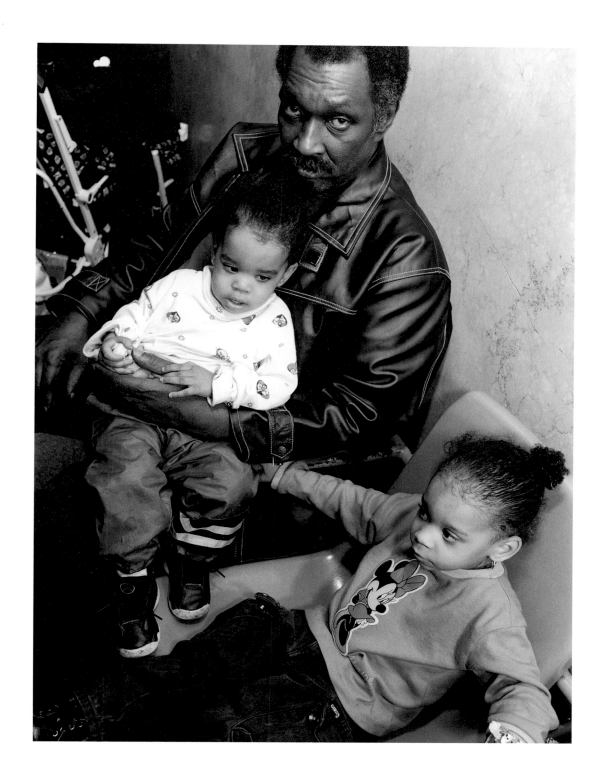

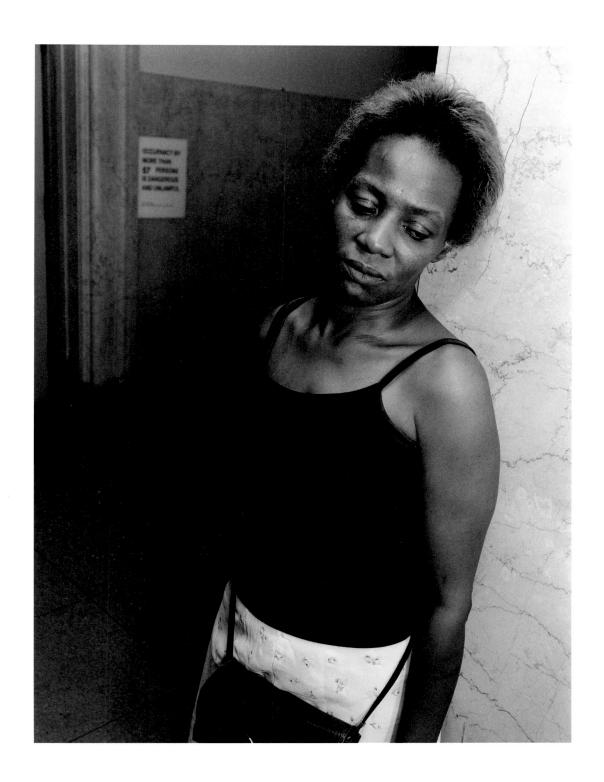

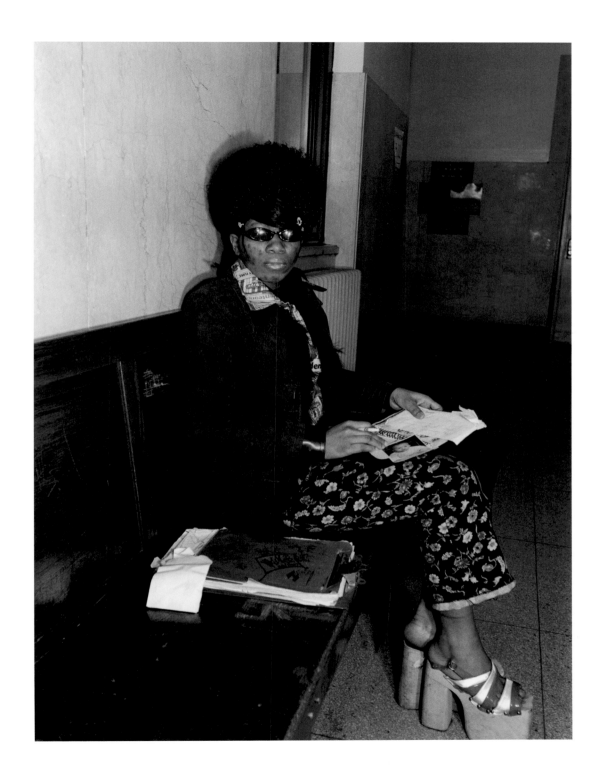

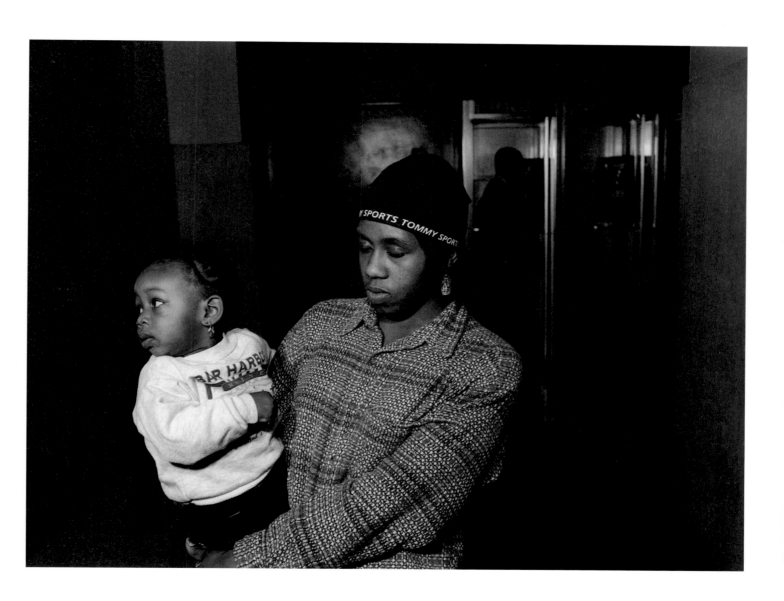

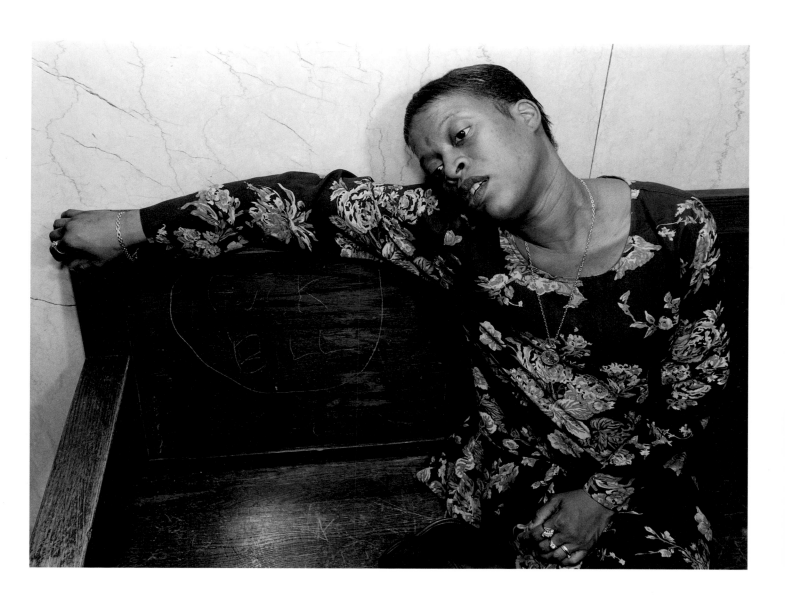

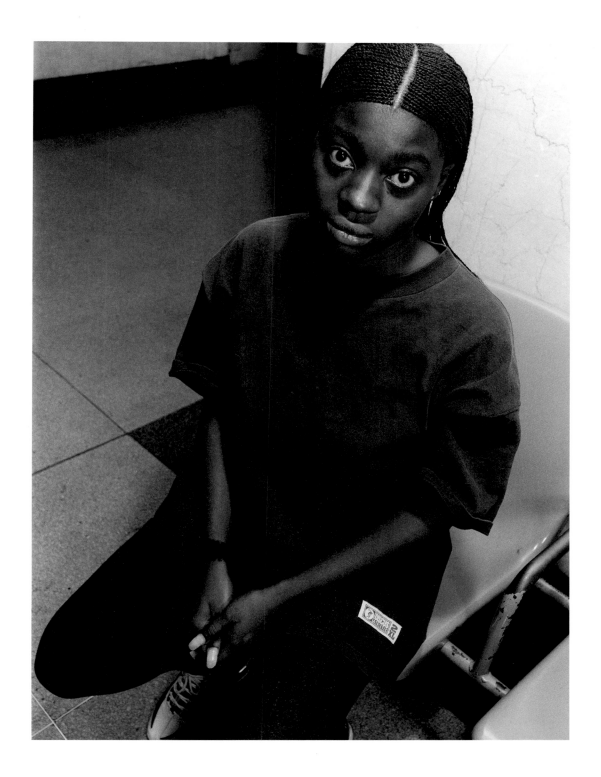

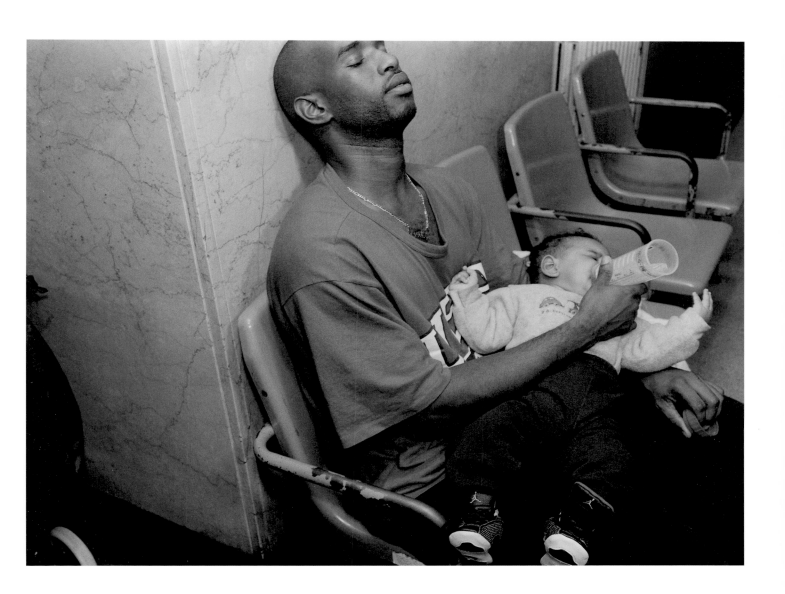

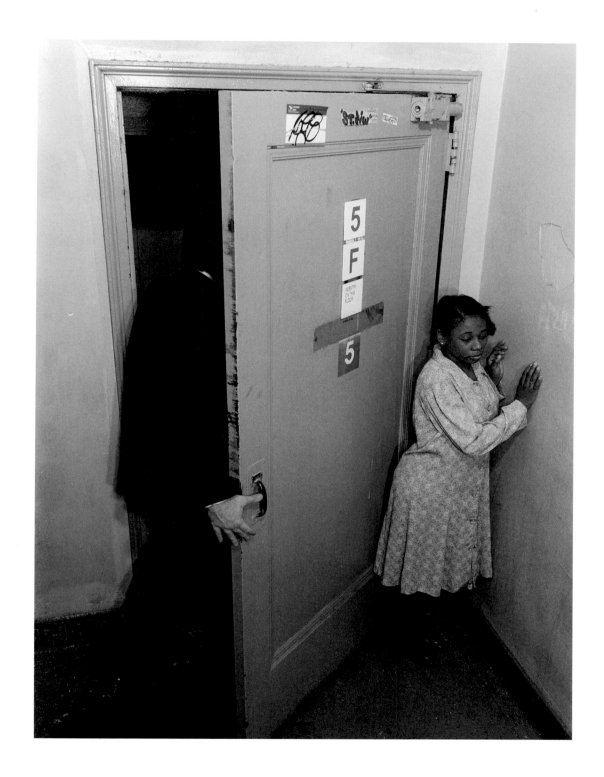

The photographs in this book were made in the Brooklyn Criminal
Court Building from December 1997 through February 1999.

ACKNOWLEDGEMENTS

First I must thank the people at court who took the time to talk with me and let me take their portrait.

I am indebted to both Judge Muriel Hubsher and Judge William Miller for encouraging me to pursue this project and for granting me permission to photograph in the hallways.

I also want to express my gratitude to Richard Benson for his technical advice and insight, to Marvin Hoshino for the design of this book, and to my publishers Daniel Power and Craig Cohen for their sensitivity and professionalism.

My special thanks to Jenny Olsson for her assistance throughout.

And finally, my heartfelt appreciation to Anna and Giancarlo, for their love and support, for driving me to and from court, and for listening to all the stories I'd bring home.

T. R.

ENDURING JUSTICE | PHOTOGRAPHS BY THOMAS ROMA

For G. W.

© 2001 powerHouse Cultural Entertainment, Inc.

Photographs © 2001 by Thomas Roma Foreword © 2001 by Norman Mailer Introduction © 2001 by Robert Coles

Published in the United States by powerHouse Books, a division of powerHouse Cultural Entertainment, Inc.
180 Varick Street, Suite 1302, New York, NY 10014-4606
telephone: 212 604 9074 fax: 212 366 5247 e-mail: justice@powerHouseBooks.com
website: www.powerHouseBooks.com

Library of Congress Cataloging-in-Publication Data:

Roma, Thomas.
 Enduring justice : photographs / by Thomas Roma.
 p. cm.
 ISBN 1-57687-102-9
 1. Documentary photography -- New York (State) -- New York. 2. Criminal courts -- New
York (State) -- New York -- Pictorial works. 3. Courthouses -- New York (State) -- New
York -- Pictorial works. 4. Brooklyn (New York, N.Y.) -- Pictorial works. I. Title.
 TR820.5.R65 2001
 779'.9347747'1 -- dc21 00-066942
 Hardcover ISBN 1-57687-102-9

Duotone scans by Gist, Inc. Typography by Marvin Hoshino Printed and bound in Italy by EBS, Verona

A complete catalog of powerHouse Books and Limited Editions is available
upon request; please call, write, or find justice on our website.

10 9 8 7 6 5 4 3 2 1
First edition
2001